IN/SIGHTS

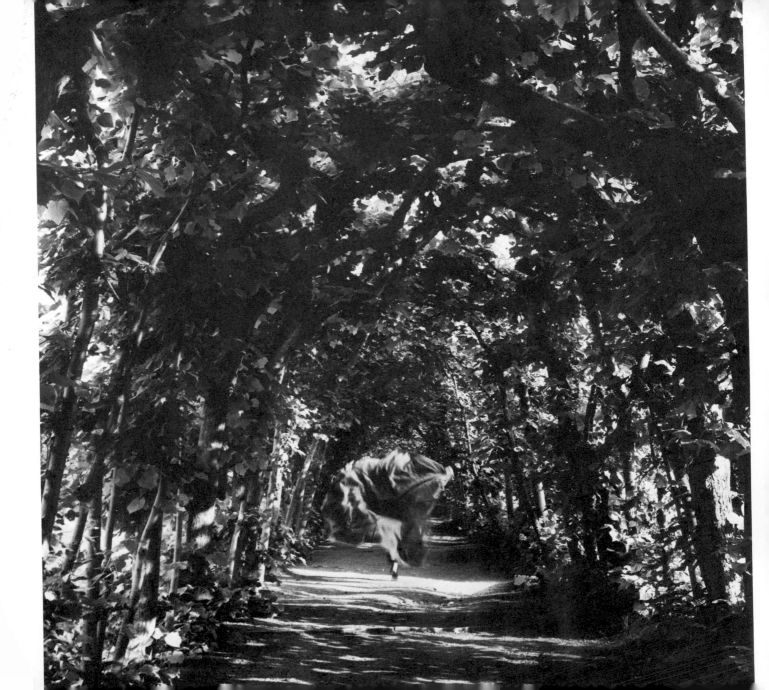

IN/SIGHTS
Self-Portraits by Women

compiled & with an introduction by
JOYCE TENNESON COHEN

with an essay by
PATRICIA MEYER SPACKS

David R. Godine · Publisher · Boston

David R. Godine · *Publisher*
306 Dartmouth Street
Boston, Massachusetts 02116

ISBN: 0-87923-246-3 (HC)
 0-87923-247-1 (SC)

LC 78-58501

IN / SIGHTS was designed by Katy Homans, typeset in
Linoterm Sabon by Bob McCoy, and printed and bound
by Halliday Lithograph. The paper is Warren's Patina.

Printed in the United States of America

CONTENTS

INTRODUCTION

Now I am a lake. A woman bends over me,
searching my reaches for what she really is.
— SYLVIA PLATH, 'Mirror'

Whether expressing itself in words, paint, collage, sculpture, or the photographic image, the autobiographical statement has emerged as a major concern of contemporary women artists. Perhaps it is simply the times, for the past decade has witnessed an unprecedented interest in the study of 'self,' while the women's movement, with its emphasis on finding and establishing a personal identity, has encouraged and legitimized this form of expression. Subjectivity and introspection, which in the past were inappropriately labeled as shallow, narcissistic, or 'feminine,' have suddenly become valued, even celebrated. Criticism of society, as well as reevaluation of roles, have become the social norms.

Given these confluences of forces, it should not be too surprising that contemporary women artists have turned with passion and conviction to self-examination, to critical introspection, and to the personal statement. And the tool that seems most accessible and immediate for exploring this new emotional territory, for charting this new terrain, is the camera.

Culled from thousands of submissions, the images on these pages comprise the first anthology of self-portraits by women ever published in any art media. It is the first attempt to show what women are really seeing—and what they are saying about what they see—when they look at themselves through the camera's eye.

I came to this project partly through my own reading. My mentors were literary. In the early 1970s, I devoured everything written by Anaïs Nin, Sylvia Plath, Virginia Woolf, and Anne Sexton. In Nin's diaries I found someone with feelings similar to my own, and this common bond helped me accept other feelings and possibilities nascent within me. A sense of identification with these authors in part led me to review my own life and profoundly affected my ability to photograph new terrain. Slowly I began using the photograph to visually record those thoughts, experiences, fears, and dreams that were most personally meaningful. The work was at times almost overwhelmingly intense as I began to directly confront, examine, and photograph my private life experiences. Yet in the process, I also became aware that by probing deeply into myself, I was also tapping something essential that touched or affected others as well.

Intriguingly, whenever I showed my self-portraits in exhibitions and slide lectures, I discovered other artists exploring similar territory. The original idea of publishing a monograph of my own work gradually evolved into the notion of assembling this anthology. For two years, I wrote letters, solicited submissions, reviewed portfolios, and selected the images that interested me most. From more than 4000 pictures submitted, 125 photographs by sixty-six photographers were chosen. In

making the final selections, I tried to be as eclectic as possible in order to reflect the striking diversity of content and style that I found.

 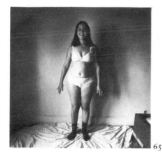

18 65

Nor was the decision to include only women merely arbitrary. It seemed rather like a natural separation, a documentation of this period of unprecedented interest by women in becoming their own image makers. I thought too that such a work might offer insight not only into women's particular perceptions, but the universal human condition as seen through women's eyes.

The book begins with portraits by sixty photographers. The second section, presenting six small portfolios by women who have worked extensively in self-portraiture, allows the viewer an opportunity to see a cohesive group of photographs by one individual. For the concluding section, each photographer was asked to present a statement analyzing her motivations and emotions in taking the photographs. Often these words have extraordinary poignance, adding focus and depth to many of the issues and themes explored visually. Yet these statements are in no way intended to 'define' the pictures; they were deliberately placed in a separate section to avoid interfering with the viewer's initial visual experience.

Although the submissions included many age groups, most came from women between the ages of twenty-five and thirty-five. I was surprised to find that less than a half-dozen of these images showed pregnant women or women with children. There were also very few pictures

of women with men, or of women confronting the camera directly, face on. What appeared most often were pictures charged with intense emotion, usually focusing on one or two selected aspects of self-investigation.

17

Hardly any photographers portrayed themselves in the passive postures of a Camille or Sleeping Beauty; in their place were images of vitality and independence, showing a willingness to confront the deepest emotions and impulses. Few of these women chose to transcribe reality in objective, documentary terms; most preferred to make internal realities external, to make public the most private aspects of their unconscious. In Elaine Fisher's words, 'My images are my personal cave paintings, symbols for my private set of interior wild animals, to be feared, remembered, recreated, and controlled.'

Within this diversity of images, however, particular themes and patterns emerge with noticeable frequency.

Self-transformation
One of the more interesting leitmotifs recurring throughout these works is the fascination with personal transformation. Different identities are continually explored and old roles exorcised through the use of masks, costumes, make-up, montage, or combination printing. Many use the self-portrait as an opportunity to try on new personalities, and then step back to see if they like the new image. Some, like Judith Golden, openly express their humor while exploring these possibilities; others, like Gillian Brown or Pamela Valois, stare out with an

obvious seriousness. Significantly, the largest number of pictures submitted fell into this category, reflecting the need to expunge sexual stereotypes and cultural expectations, or perhaps to disguise them.

 89 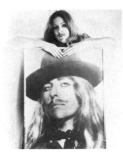 27

Exploration of sexuality

Direct visual confrontation with one's body is often used to explore personal feelings and attitudes about sexuality. Photographs in this category constituted the second-largest group submitted; this was also the group most uneven in quality. For many, the act of just appearing nude in a photograph seemed an end in itself, an act of almost profligate willfulness, a misconceived icon of

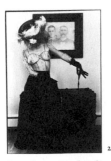 20 40

freedom. In duplicating or imitating the clichés of the popular media, were these photographers expressing a basic ambivalence about female sexuality? As art critic Lucy Lippard comments, 'Because society hasn't radically changed for women, what we're seeing is a mixture of what women really want to do and what they think they

should do.' Fresh, innovative images in this area by photographers like Soledad Carrillo Shoats and Rosalind Kimball Moulton are welcome indeed.

Incorporation of natural forms

Many photographers use the figure as an element in compositions containing rocks, trees, roots, and water, maintaining a particular interest in the texture and sensual

 5

qualities of these forms. In these pictures, one can sense a desire for a close relation, or even fusion, with natural phenomena: many images achieve an almost ritualistic effect. The near absence of the urban landscape, a prominent theme in much other contemporary photography, is especially striking.

Nostalgia & the past

Family snapshots, objects from past history, nostalgic

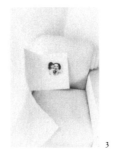 3 29

settings, and superimposed images originally separated in time are used in diverse ways: to explore personal

roots, to re-examine what did or did not take place, to fantasize about what might have been. For Bernis von zur Muehlen, the past symbolizes security, a time of less conflict, a way of remembering someone lost in memory. For Hildy Pincus, an empty couch and a portrait of two people produces 'a sad memory, a loss, an emptiness I can't explain.'

Fears & the unsettling
Using startling, macabre, or disquieting images can be a way of objectifying and confronting fears. De Ann Jennings' pictures deal with issues which many people might find shocking and distasteful, yet her ideas come not only from her inner psyche but also from media coverage of everyday events. Her photo of a person stitched into a

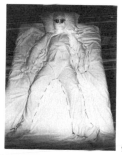

96 95

sheet, for example, was inspired by a newspaper article about a wife who stitched her husband in the bedsheets to keep him from going out. Jennings calls her images satirical one-act plays, and describes her work as being 'a little like a car accident—you're kind of afraid to look at it, but you're attracted at the same time.'

Conscious & unconscious archetypal imagery
A number of the photographers spoke of being overwhelmed by an unconscious image or feeling so strong that they were literally forced to express it. Others, like Mary Beth Edelson, deliberately incorporate archetypal symbols into their work. While Edelson used her early self-portraits to explore her personal identity, her later

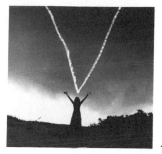
46

works investigate those aspects of self which represent 'Every Woman.'

Formal visual issues
Using the body or body fragment and relating it to shape, line, texture, and pattern is historically an im-

6

portant artistic concern. For example, in Ann Mandelbaum's pictures her own body is used not as the central focus, but as one integral element of visual exploration.

Dreams & fantasies
Many photographers make direct use of dreams or fantasies to record events that took place only in their minds. Bea Nettles places herself in reconstructed situations in which she says she can fantasize her actual presence 'mainly because of the believability of the photographic product.' Many of my own images derive from a dream that I then relive and crystallize through the photographic image. The picture here was actually taken immediately after a powerful dream I had of walking through a dense fog with a birdcage. I awoke suddenly feeling tense, not able to remember if the cage door was open or closed.

Glancing out the window, I saw an incredibly heavy fog, and with great excitement, I rushed outside picking up a birdcage I had bought six months earlier. This picture

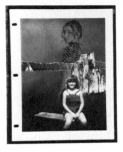

101

109

emerged effortlessly. Many months later I realized it was a metaphorical equivalent for the internal struggle I was going through at the time about personal freedom.

Humor & satire
Satire, along with unexpected and delightful flashes of humor, pervades much work in this collection. Photographers who have been working in self-portraiture over time seem more likely to take pictures maintaining a sense of humorous detachment. Perhaps it is experience that brings one to a perception similar to Gertrude Stein's, written across the bottom of Skyler Rubin Posner's picture: 'There ain't any answer, there ain't gonna be any answer, there never has been an answer, that's the answer.'

It would be impossible to enumerate all the forces which motivate self-portraiture. For some, these images represent emotional counterpoints, for others, a form of visual diary, or documentation of a particular place, event, mood, or time. Sometimes it is as simple as the self being the only available model, the only accessible role. For many, a portrait is a 'souvenir' of the precious moment, real or fantasized; for others, it presents an opportunity to penetrate more deeply into human character by examining its primary manifestation, the self. For all, the lens becomes a mirror reflecting both inner vision and outer presence. It records with the same dispassion it reflects. As da Vinci commented, 'The mirror, above all, the mirror is our best teacher.'

—JOYCE TENNESON COHEN

THE PHOTOGRAPHS

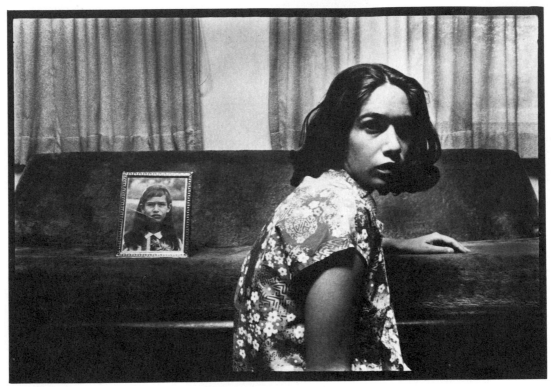

EVE KESSLER

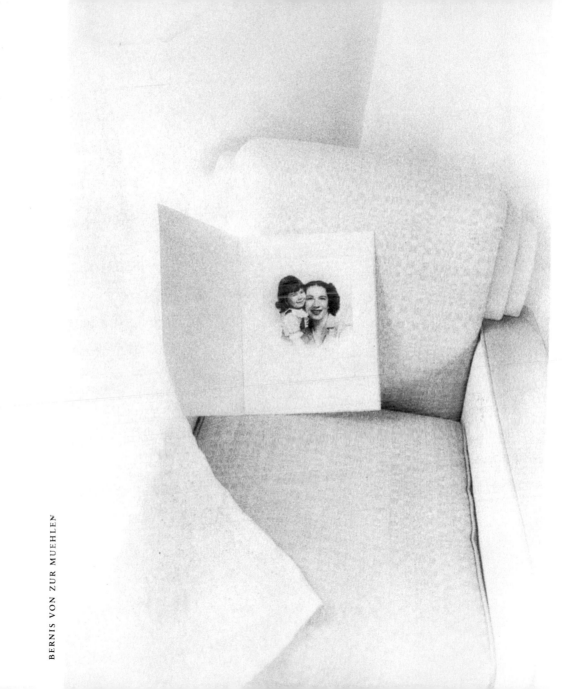

BERNIS VON ZUR MUEHLEN

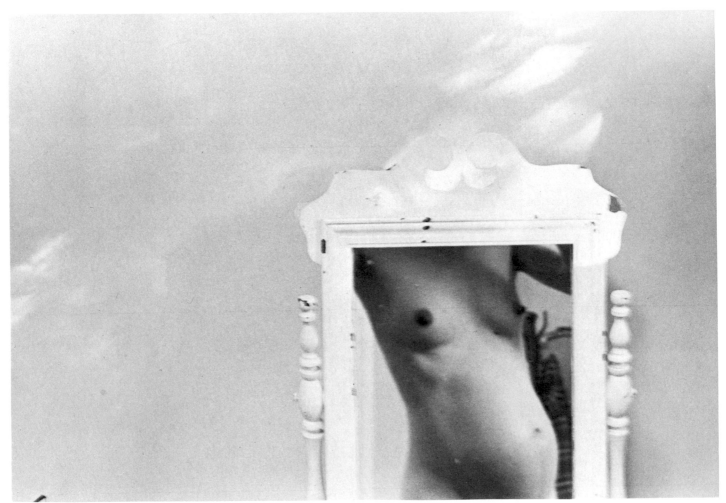

PATRICIA HURLEY

SUSAN BRANSFIELD

5

ANN MANDELBAUM

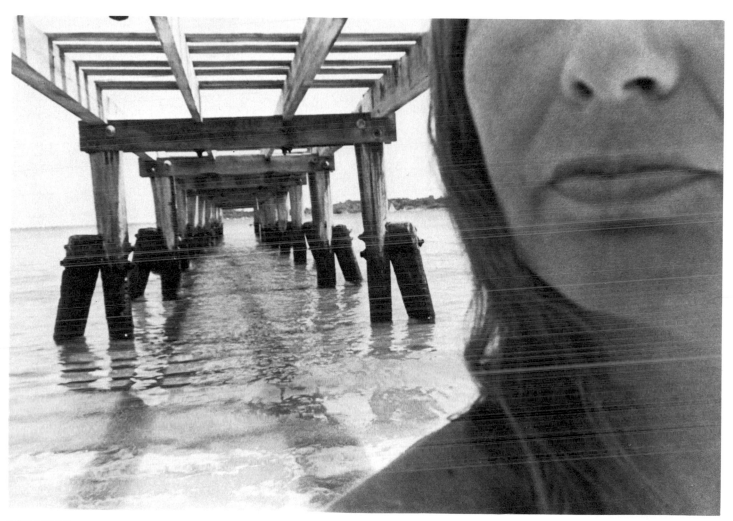

CHRIS ENOS

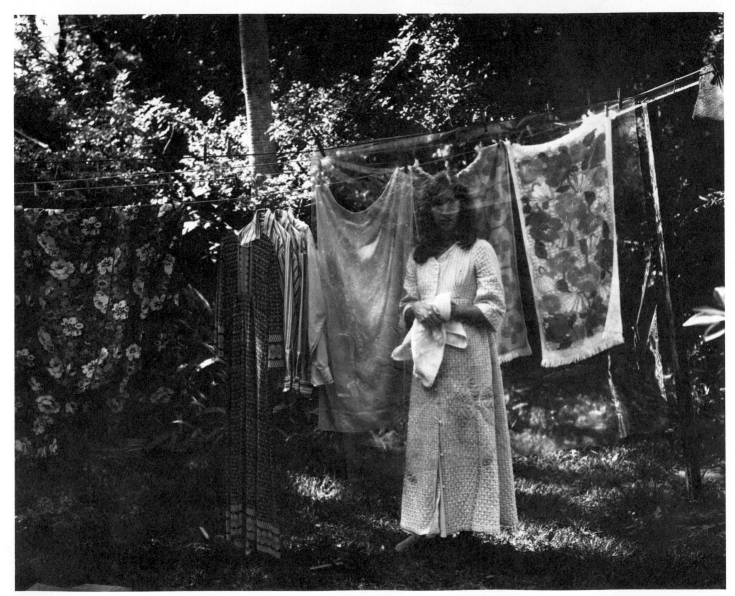

SUZANNE CAMP CROSBY

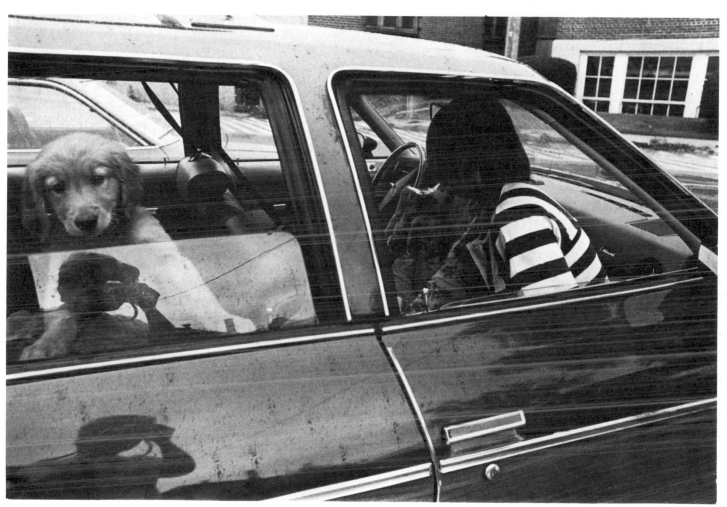

CHRISTINE PAGE

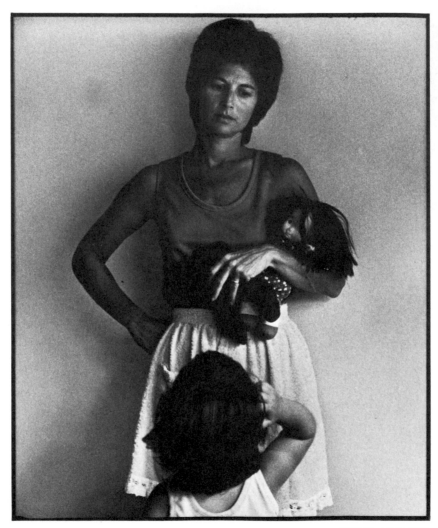

ETHEL DIAMOND

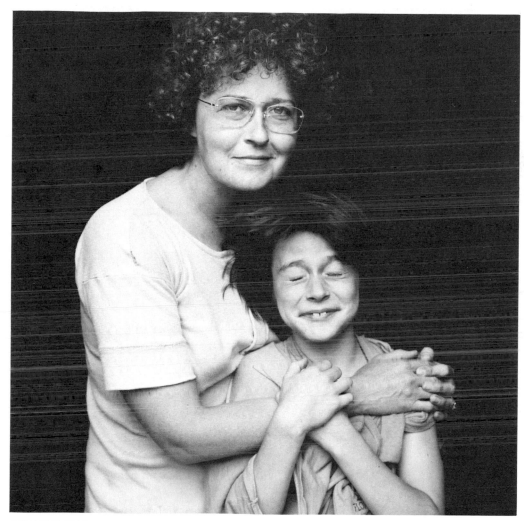

SUZANNE EMOND

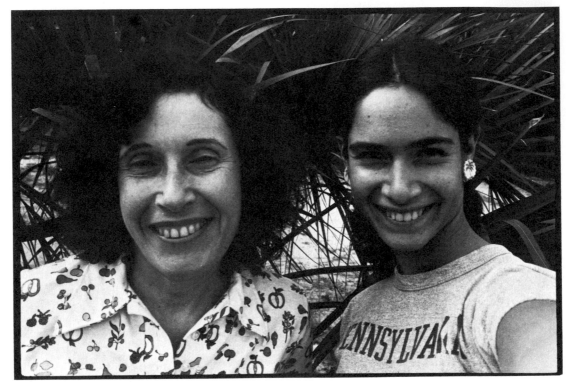

EVE KESSLER

I always wanted to look like my father.

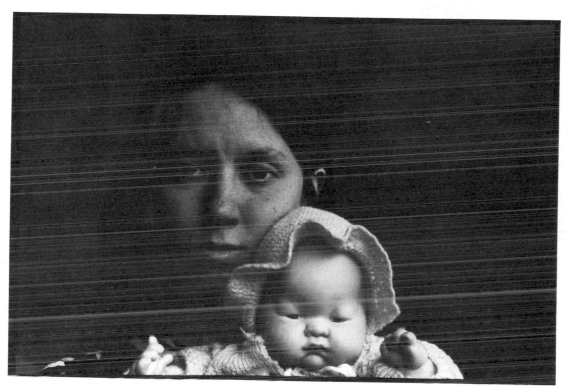

KAREN A. PEUGH

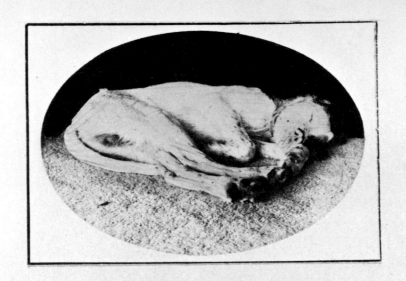

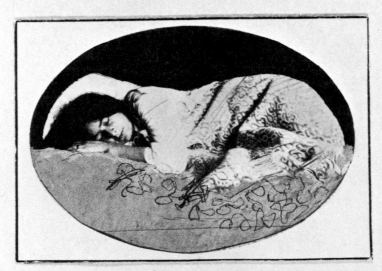

Joanne Leonard '74

Variations on a Sleeping
Theme – With Polaroid Selfportrait

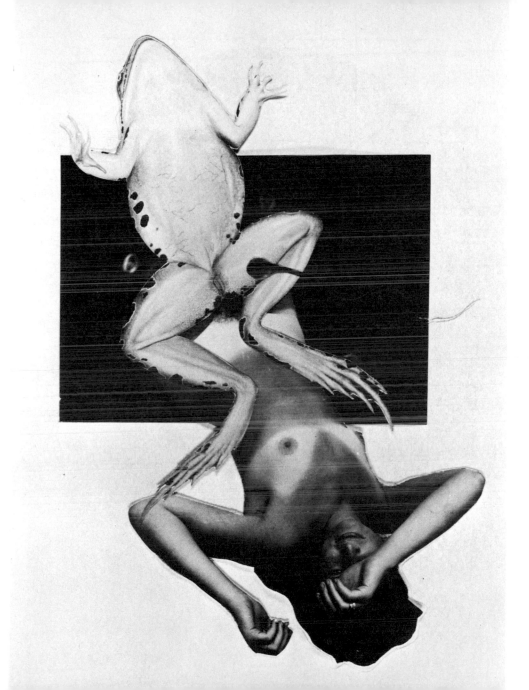

JOANNE LEONARD

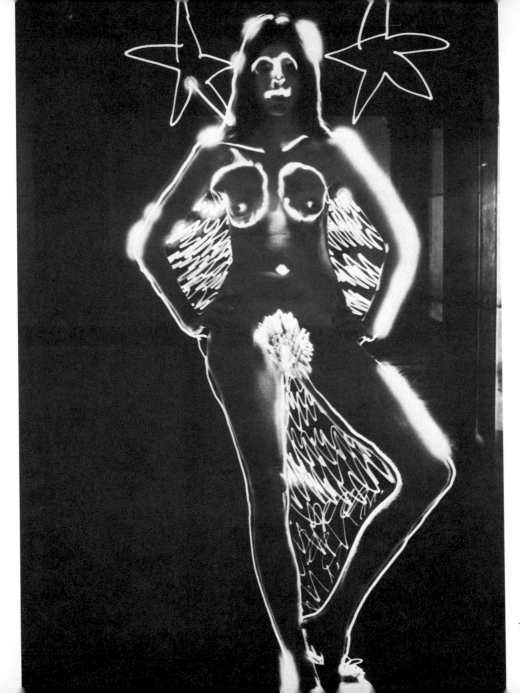

TESSIE DANIELS

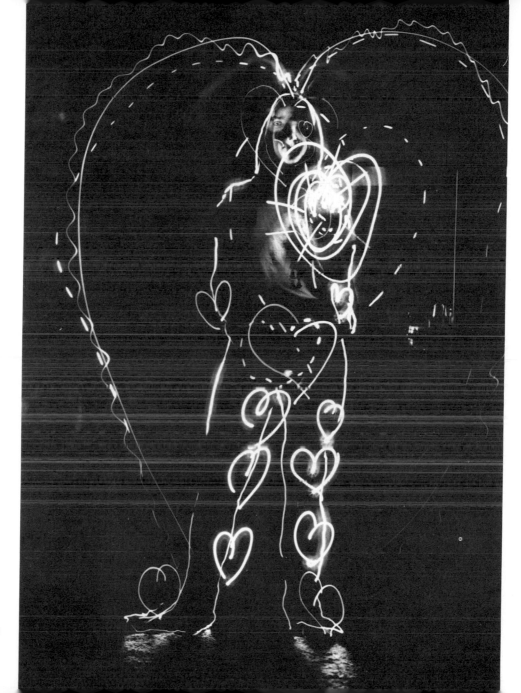

TESSIE DANIELS

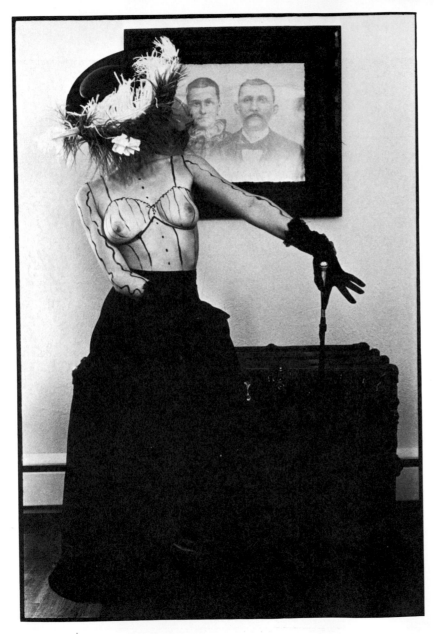

SOLEDAD CARRILLO SHOATS

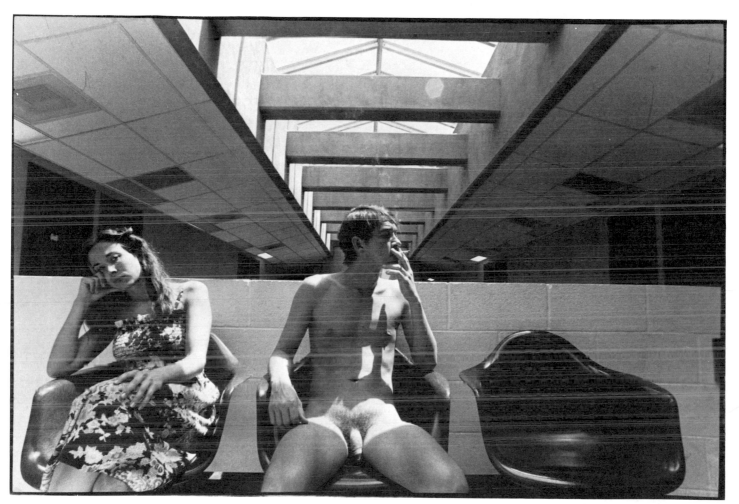

SOLEDAD CARRILLO SHOATS

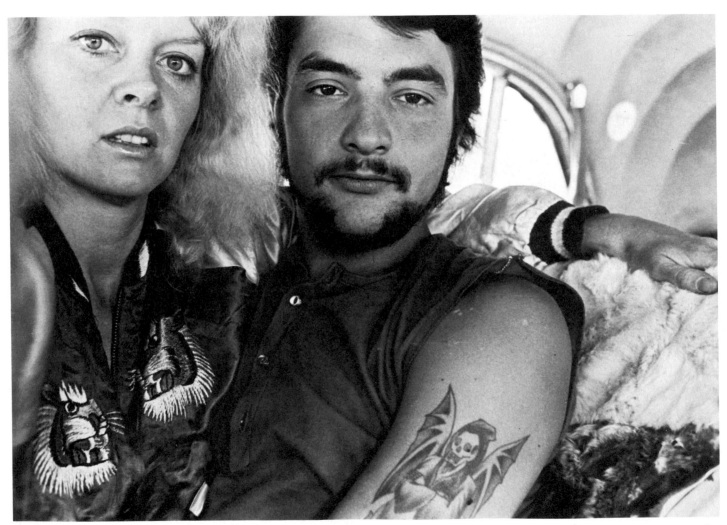

CHERIE HISER

22

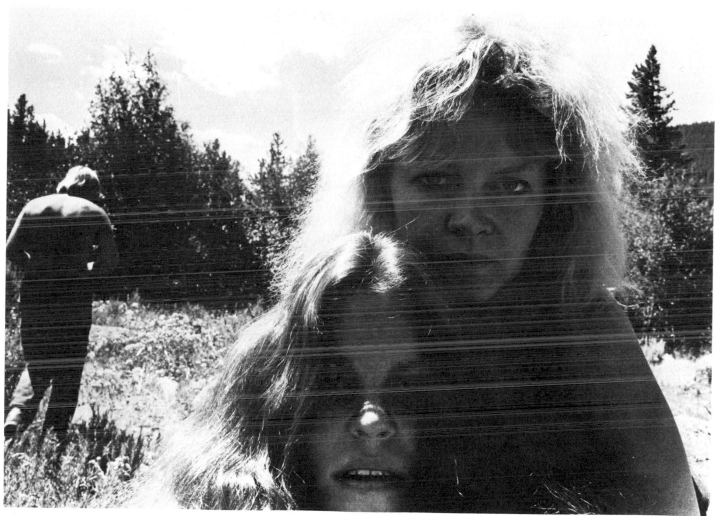

CHERIE HISER

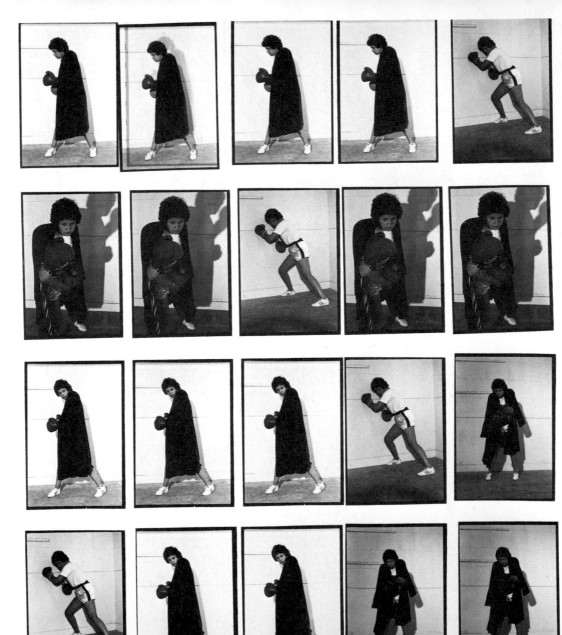

NAOMI WEISSMAN

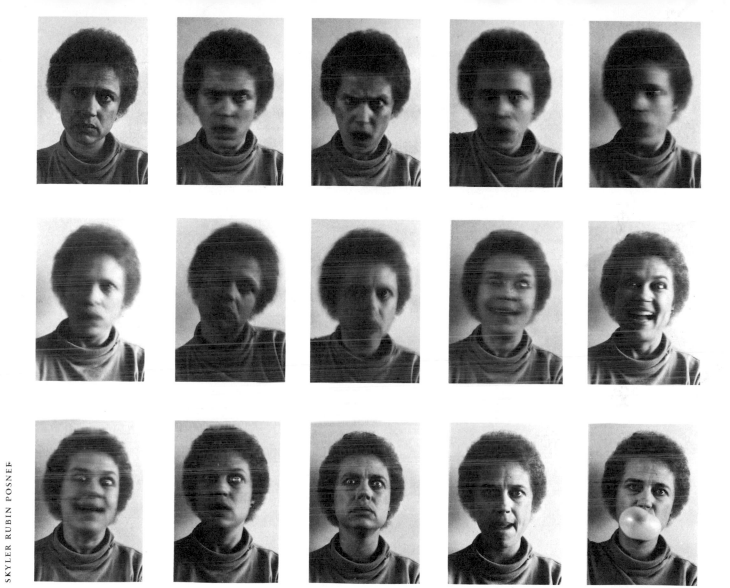

THERE AIN'T ANY ANSWER, THERE AIN'T GOING TO BE ANY ANSWER,
THERE NEVER HAS BEEN AN ANSWER, THAT'S THE ANSWER.

...GERTRUDE STEIN

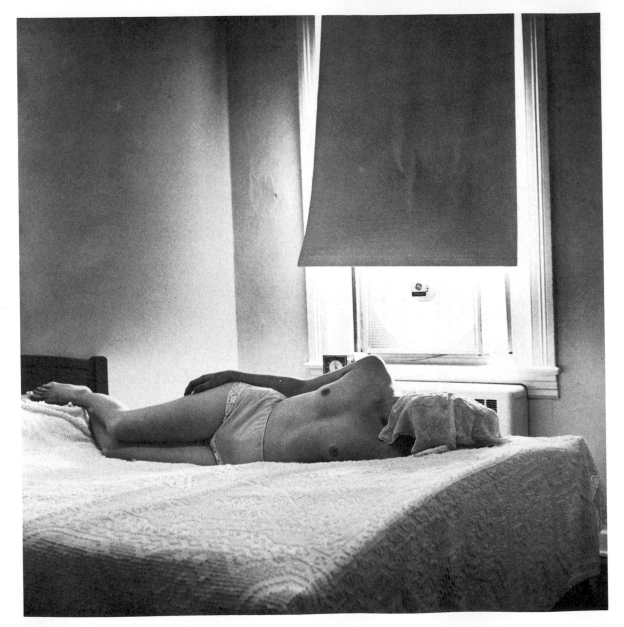

CHRISTINE OSINSKI

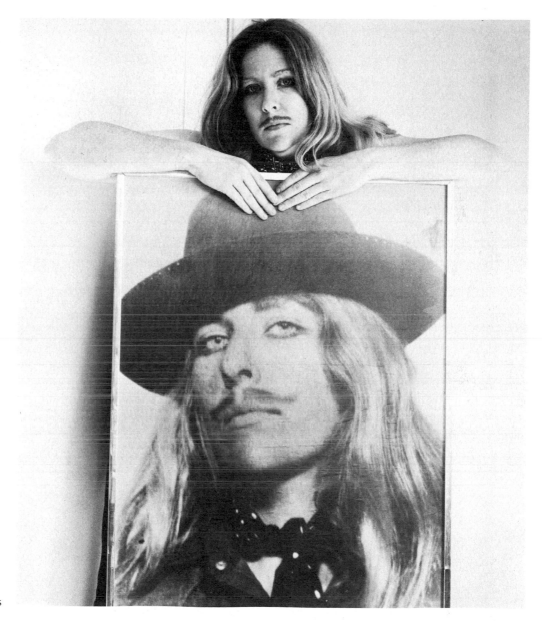

PAMELA VALOIS

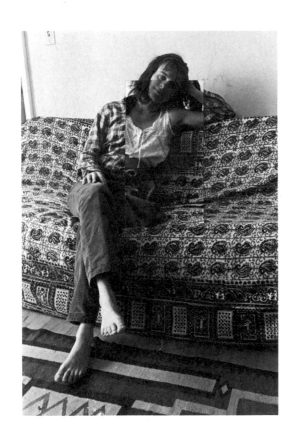

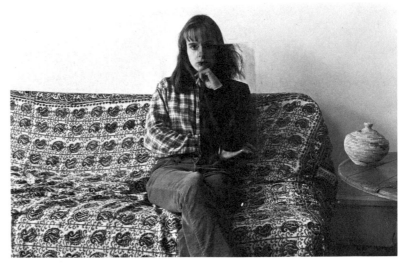

GILLIAN BROWN

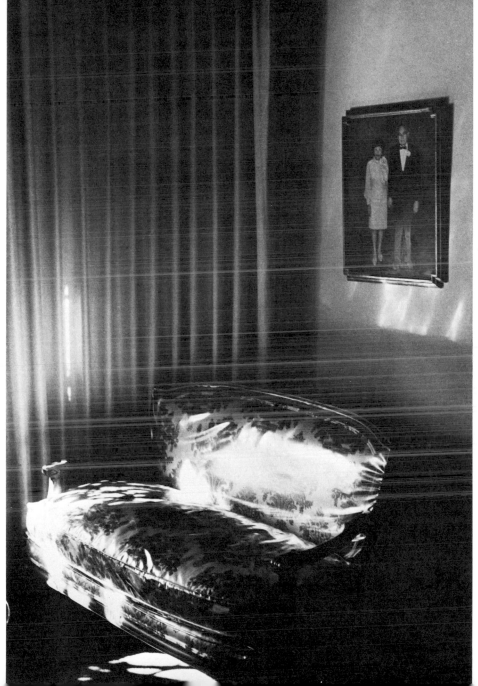

HILDY PINCUS

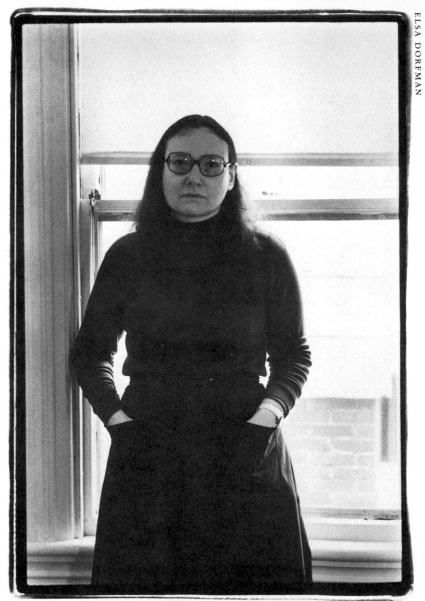

My thirty-ninth birthday — Dorfman

30

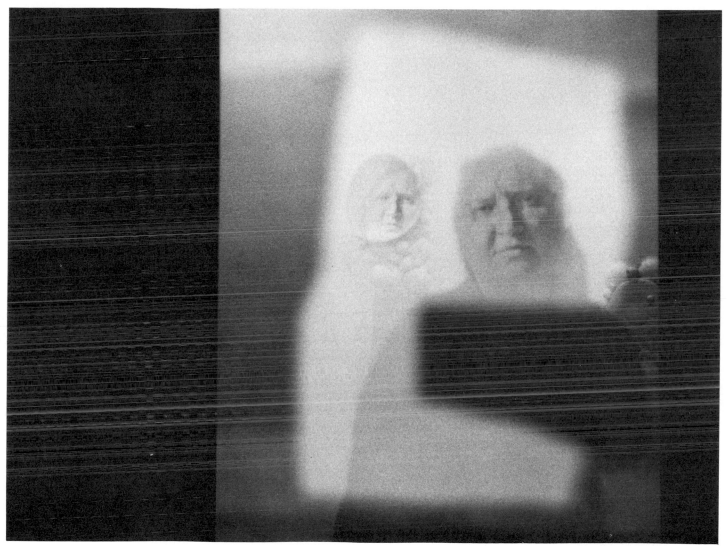

ELAINE FISHER

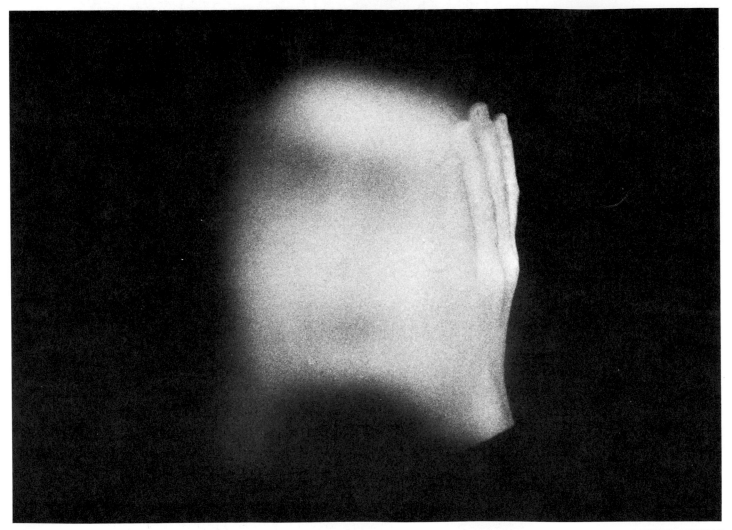

CAROL MURRAY

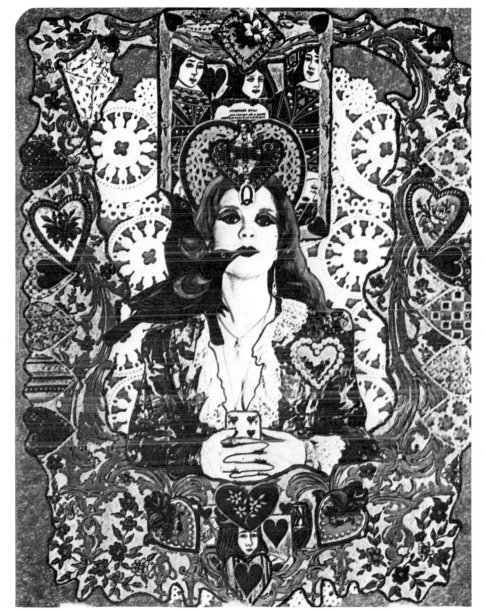

JILL LYNNE

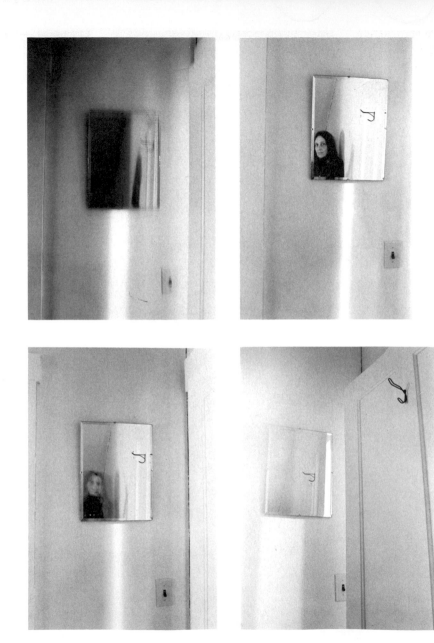

JUNE ASCHENBACH

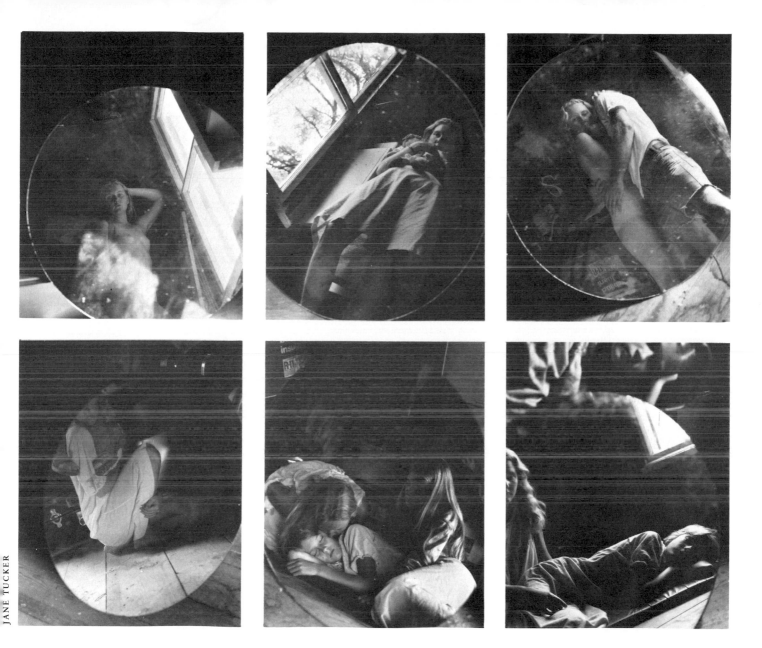

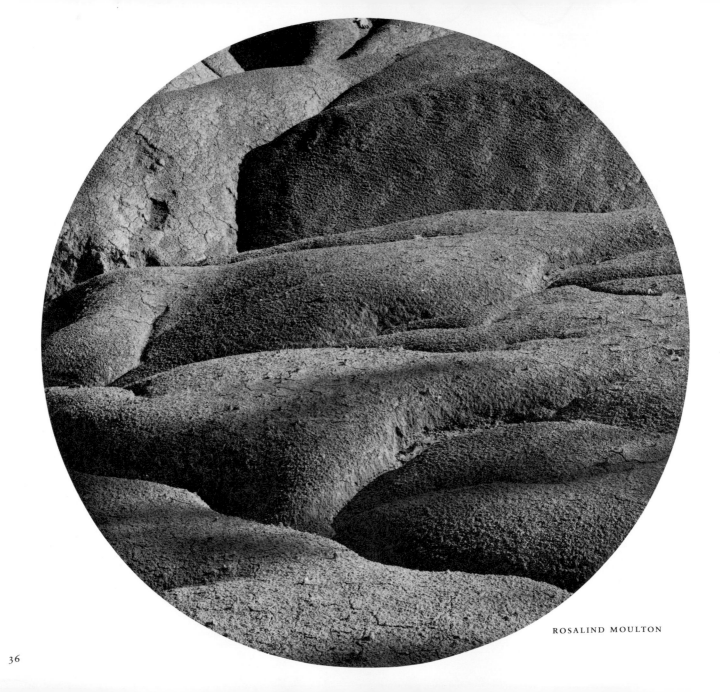

ROSALIND MOULTON

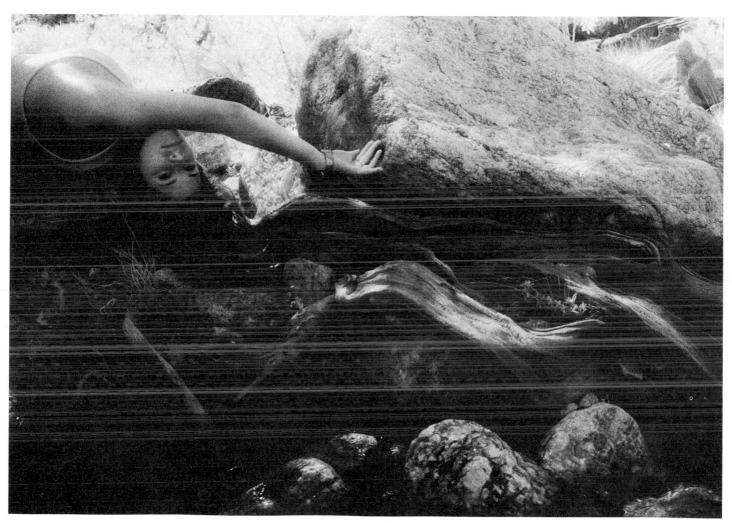

LINDA J. SCHWARTZ

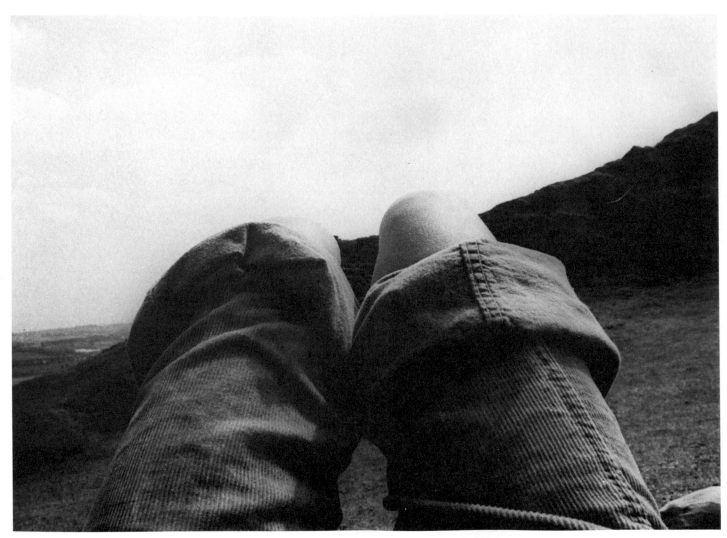

ANN MANDELBAUM

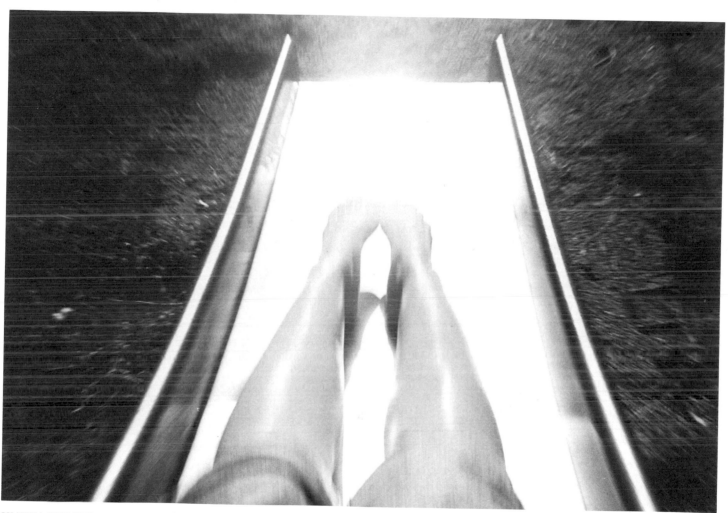

SHAWNA REILLEY

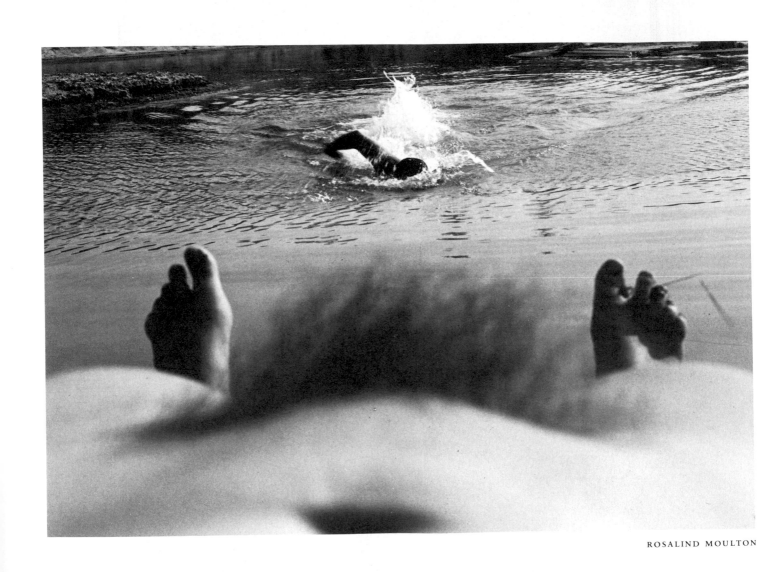

ROSALIND MOULTON

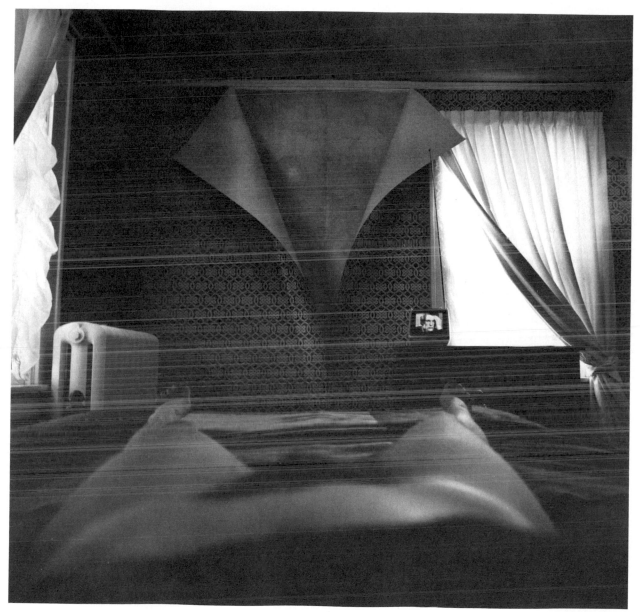

VICKI RAGAN

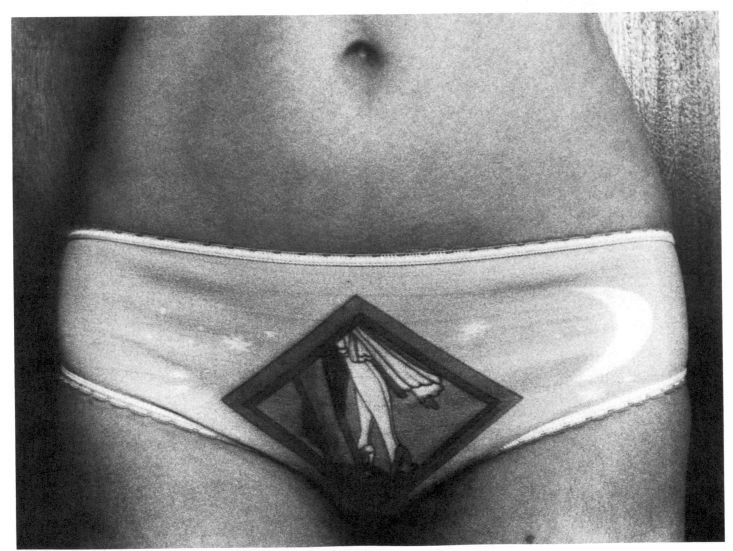

LINDA BENEDICT-JONES

42

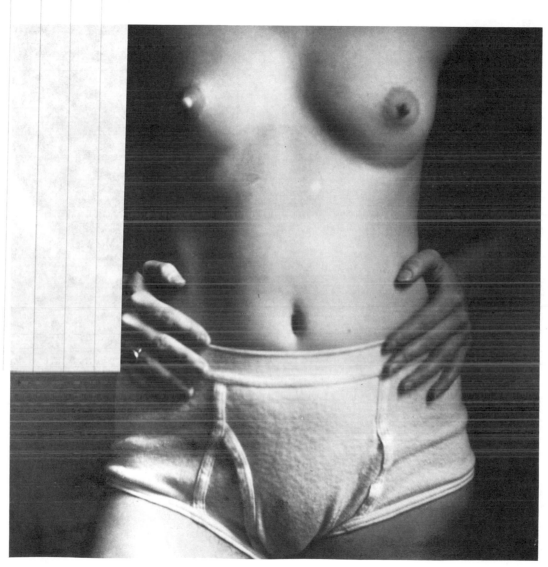

KATHY MORRIS

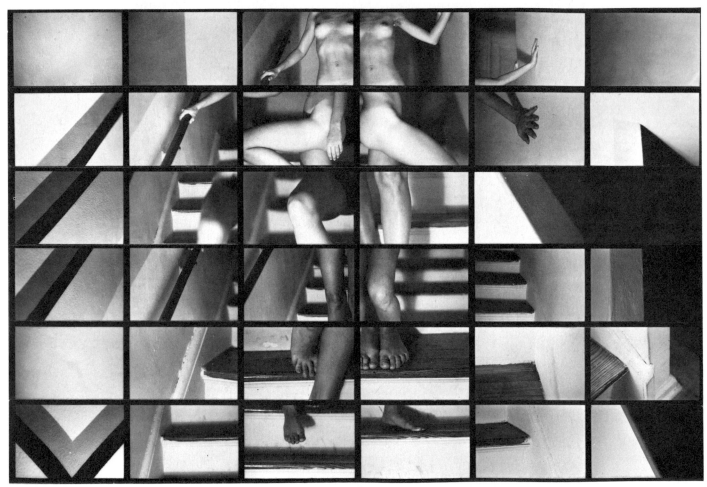

LINDA LINDROTH

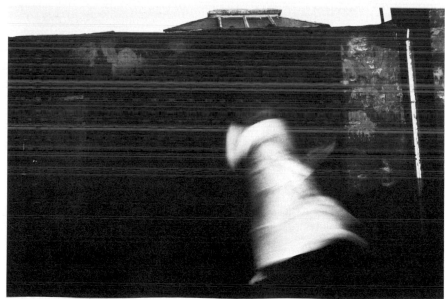

CATHERINE GARDINER ALLPORT

45

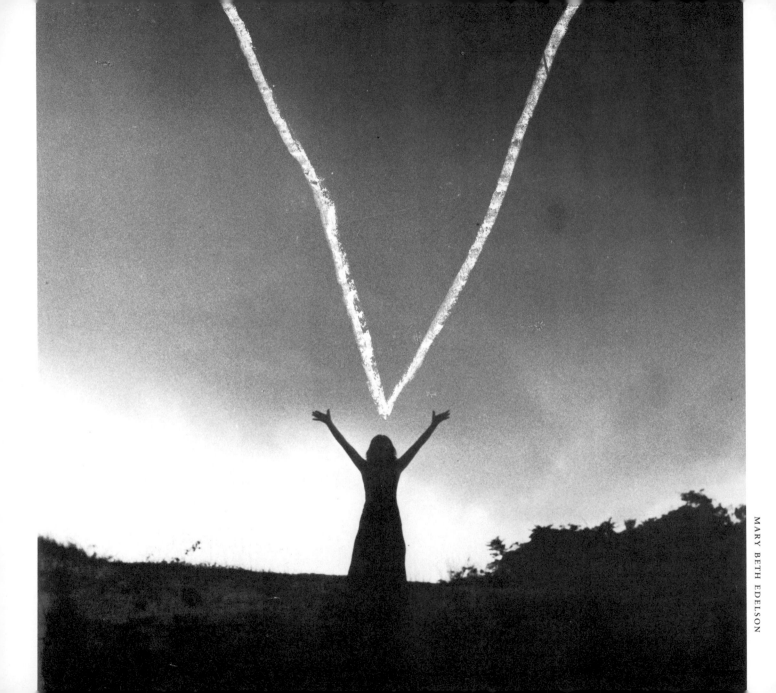

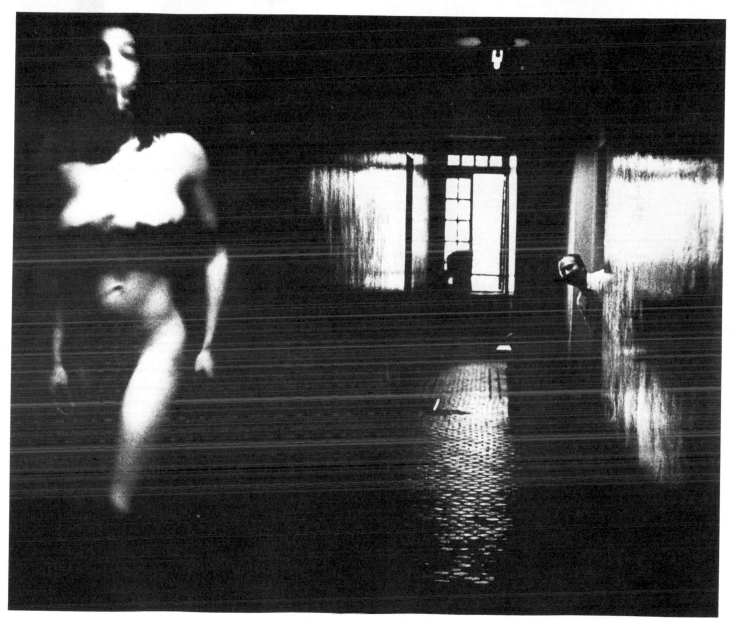

EILEEN BERGER

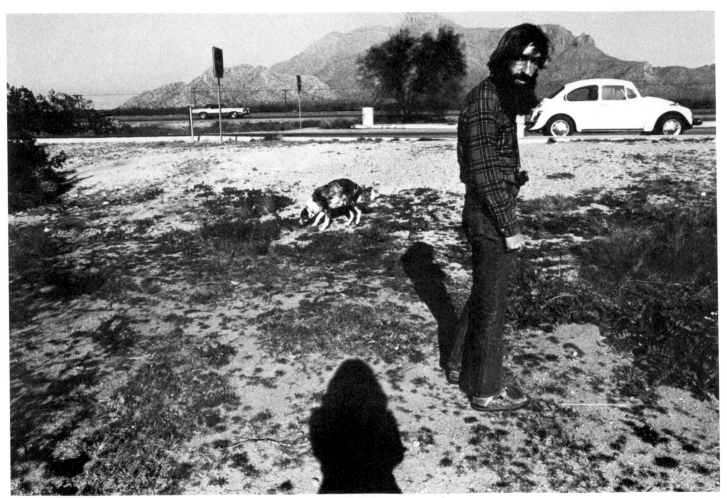

ANN F. WENZEL

JOYCE JOHNSTON

 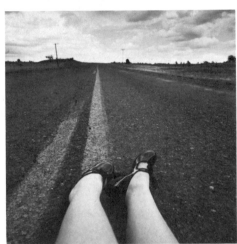 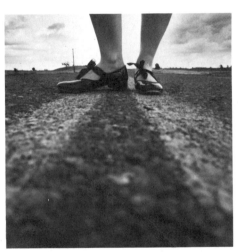

VICKI RAGAN

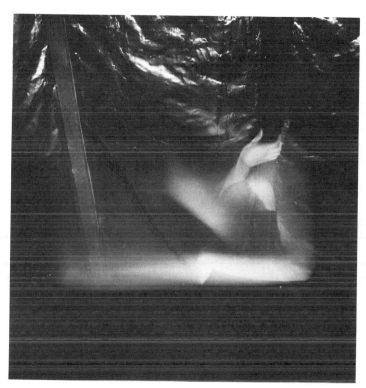 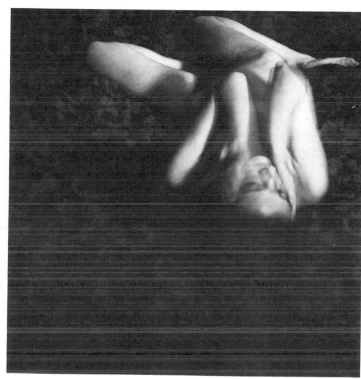

ANNE-CATHERINE FALLEN

M T W T F S S

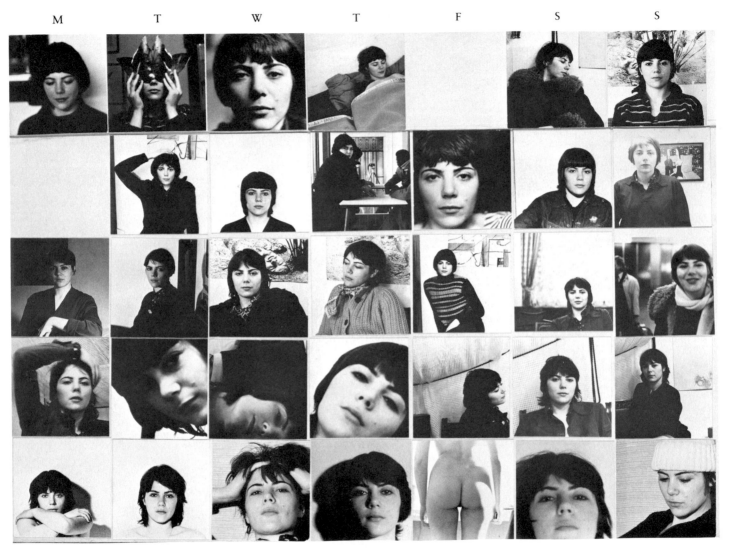

FRIEDL BONDY

M T W T F S S

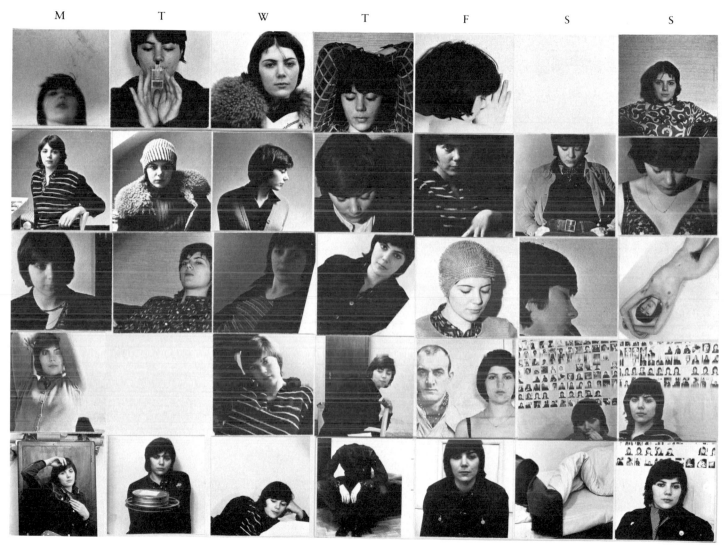

FRIEDL BONDY

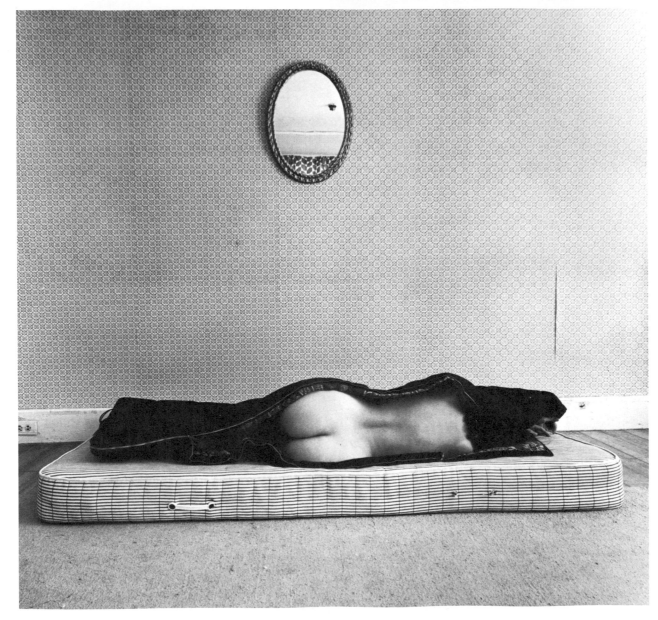

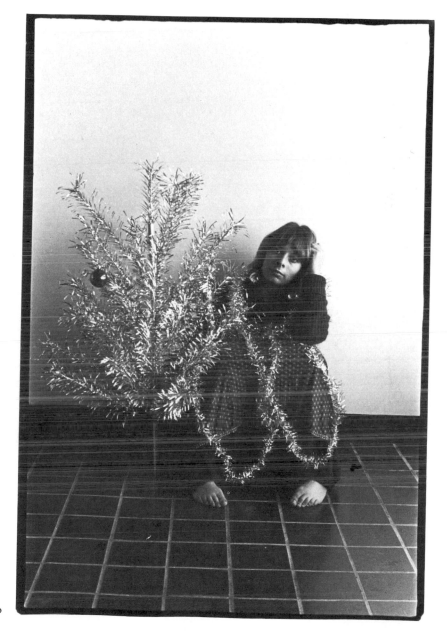

KATRINA LASKO

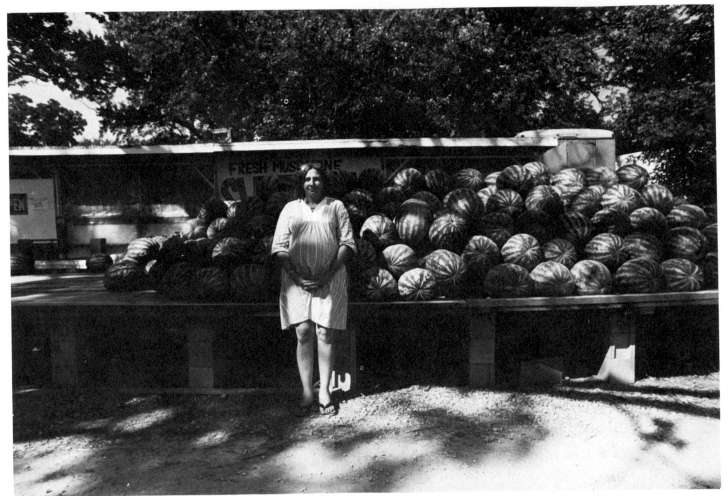

CHERYL YOUNGER

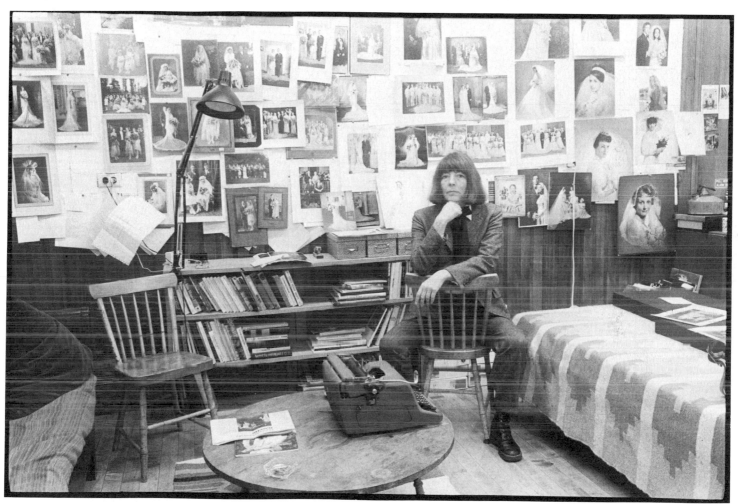

BARBARA NORFLEET

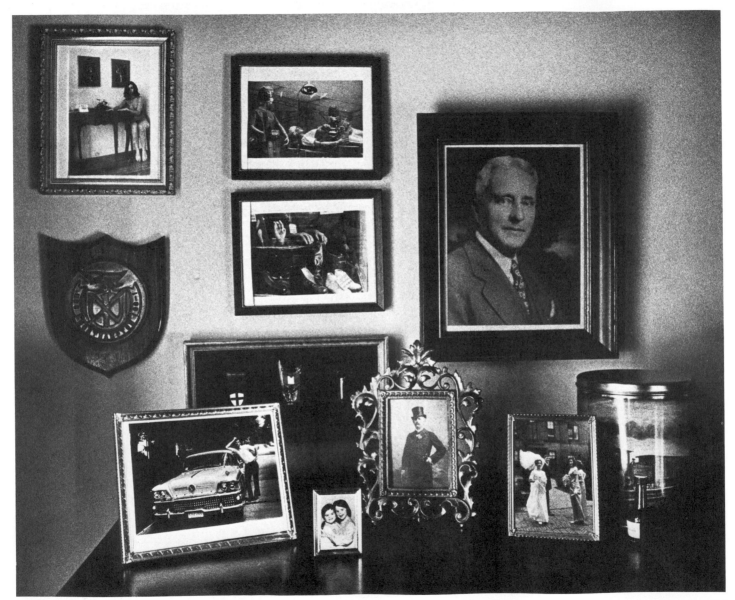

MARY PITTS

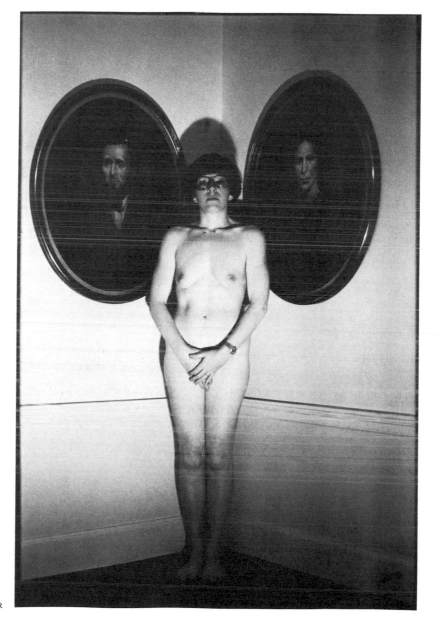

C. K. OPPENHEIMER

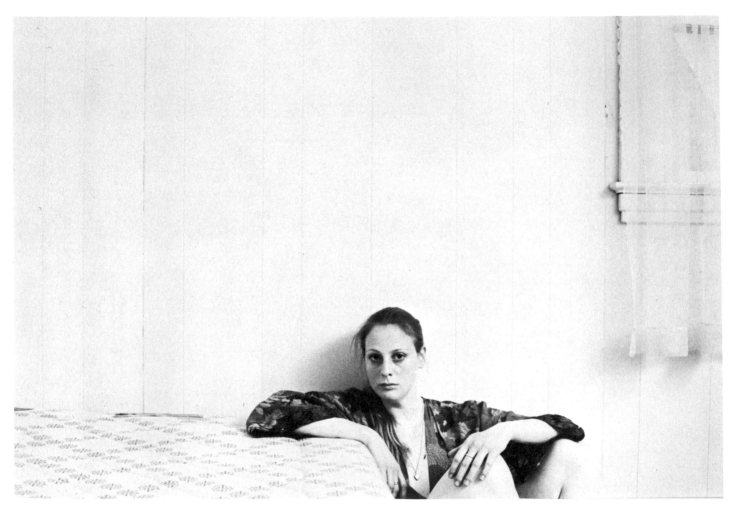

JUDY NATAL

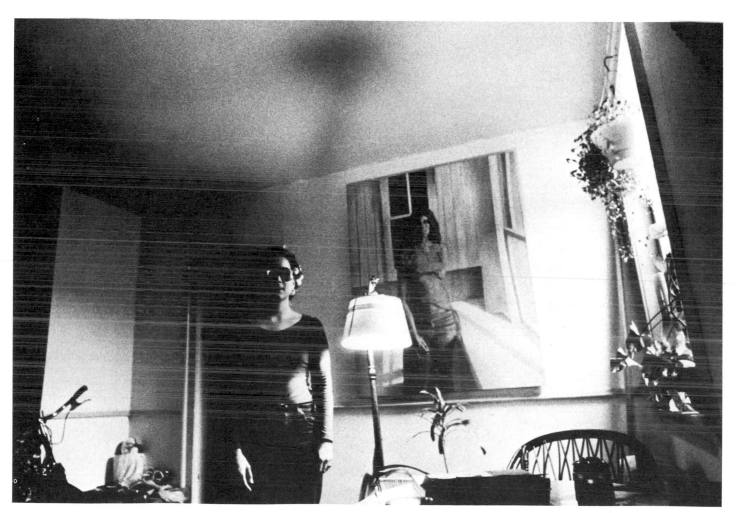

MARILYN SZABO

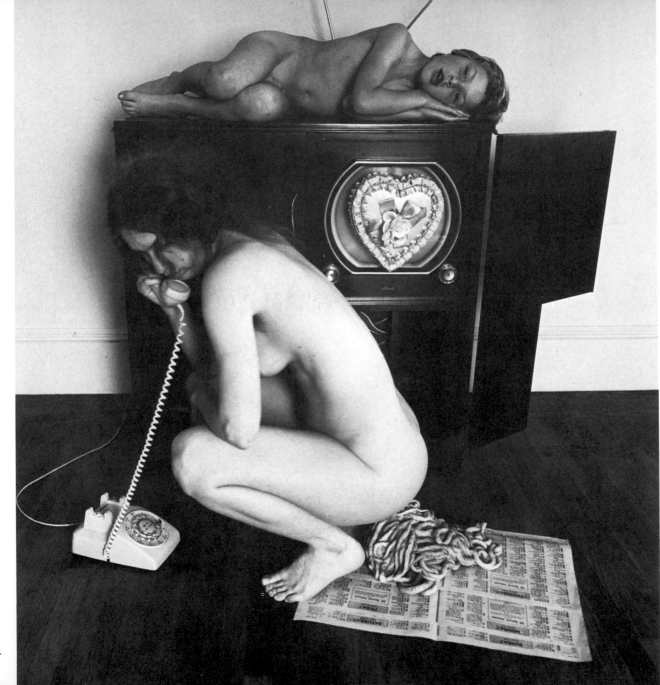

JACQUELINE LIVINGSTON

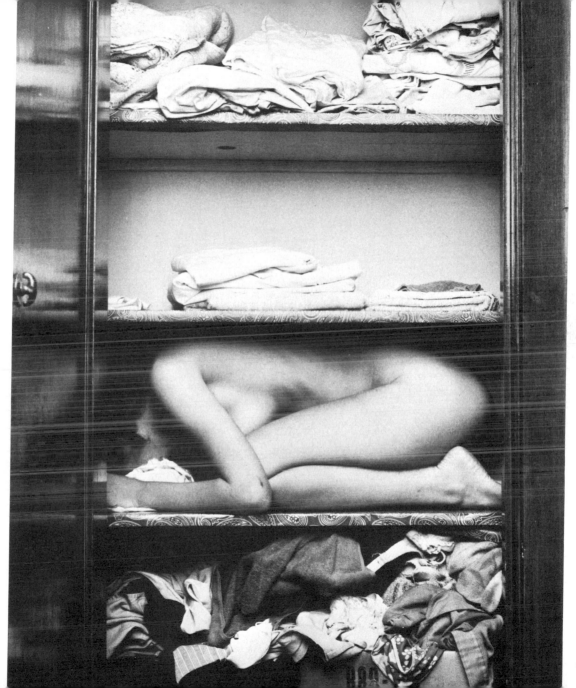

KAREN PLESUR

63

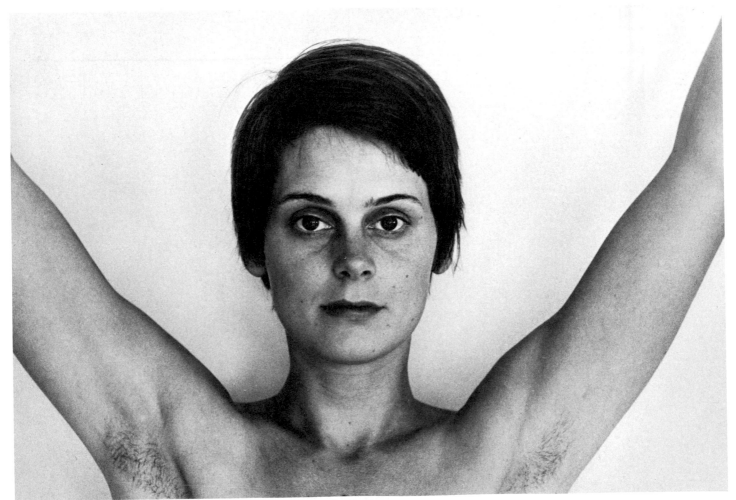

KAREN CLEMENS

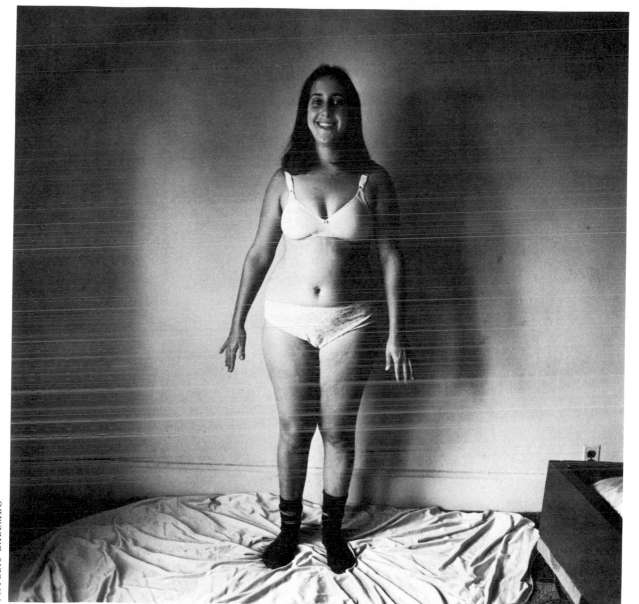

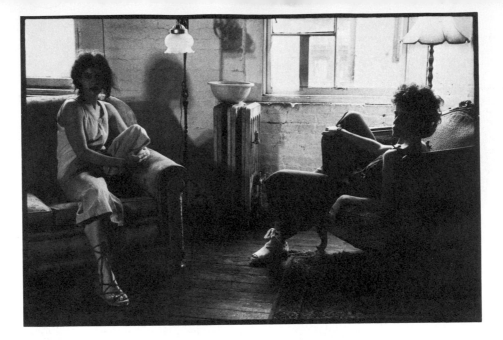

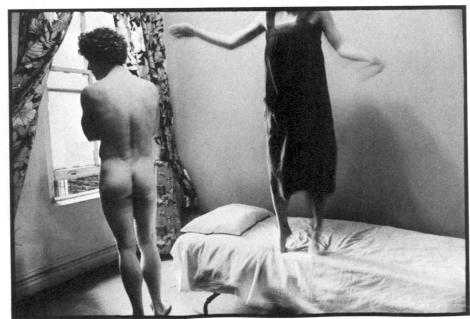

JANE SCHREIBMAN

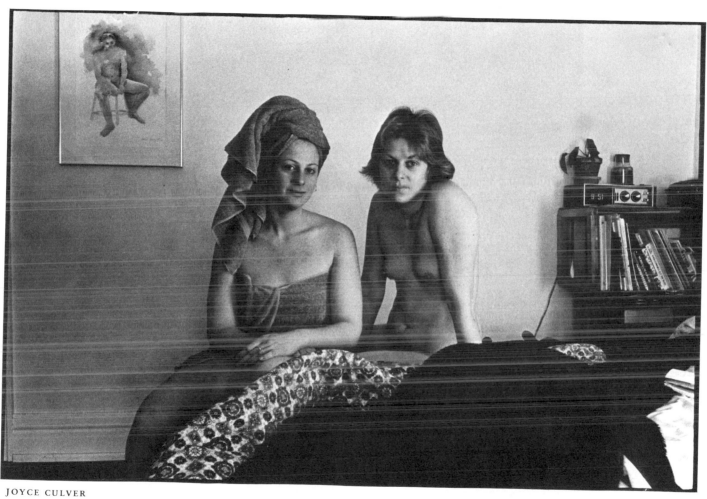

JOYCE CULVER

CYNTHIA PARARO

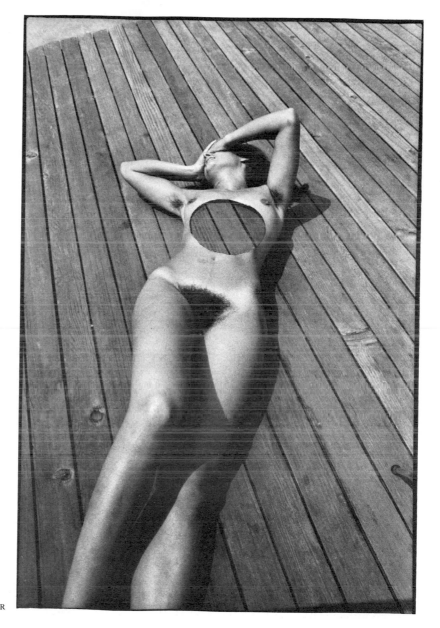

DINAH BERLAND PORTNER

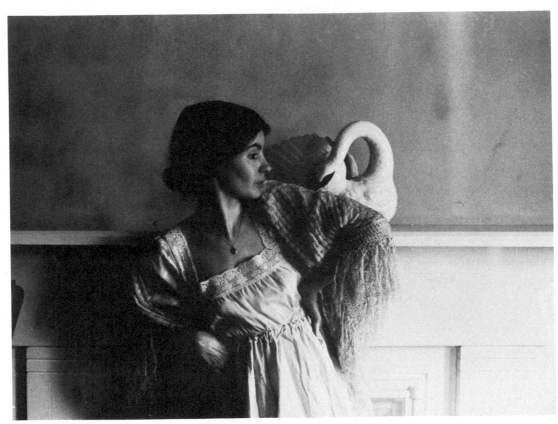

HONOR CONKLIN

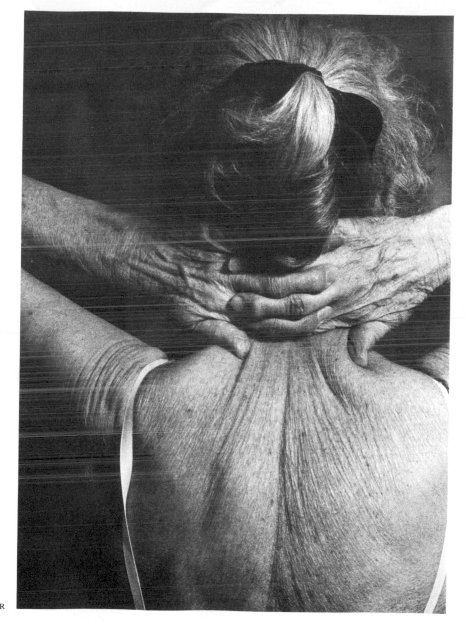

NINA HOWELL STARR

SIX PORTFOLIOS

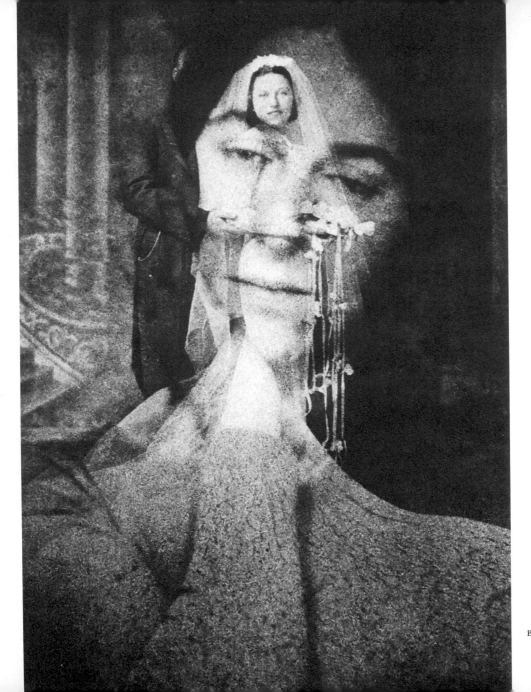

BOBBI CARREY

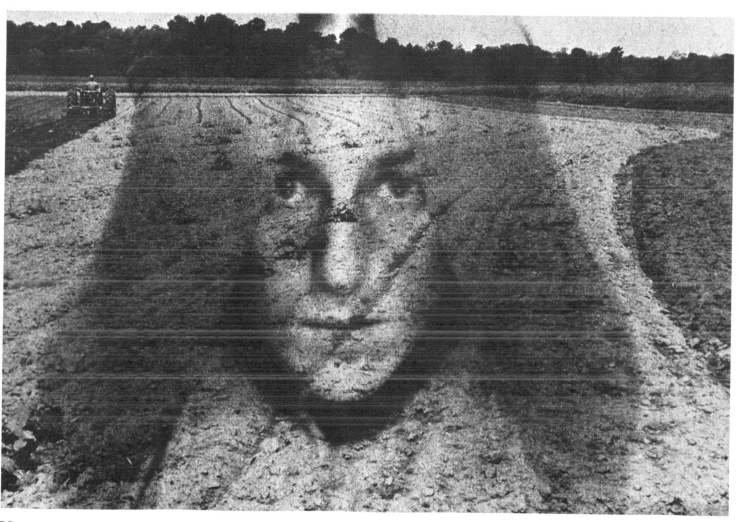

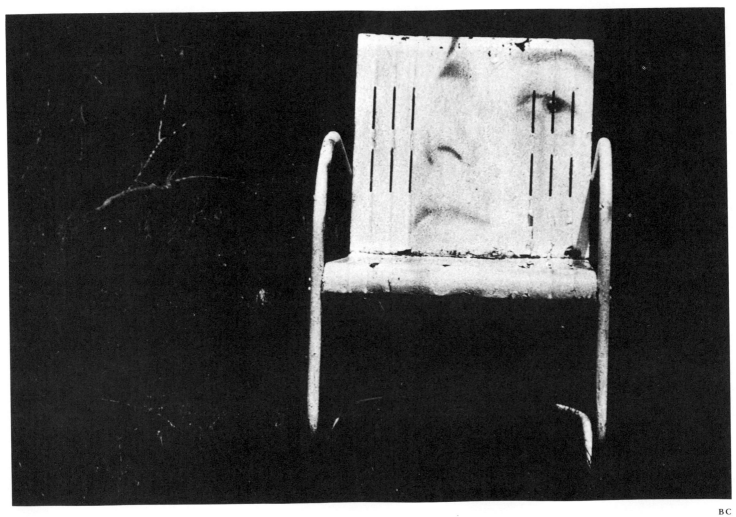

BC

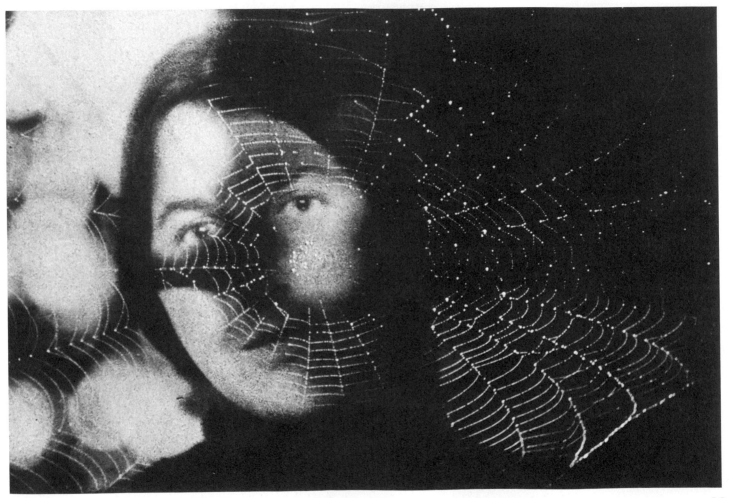

BC

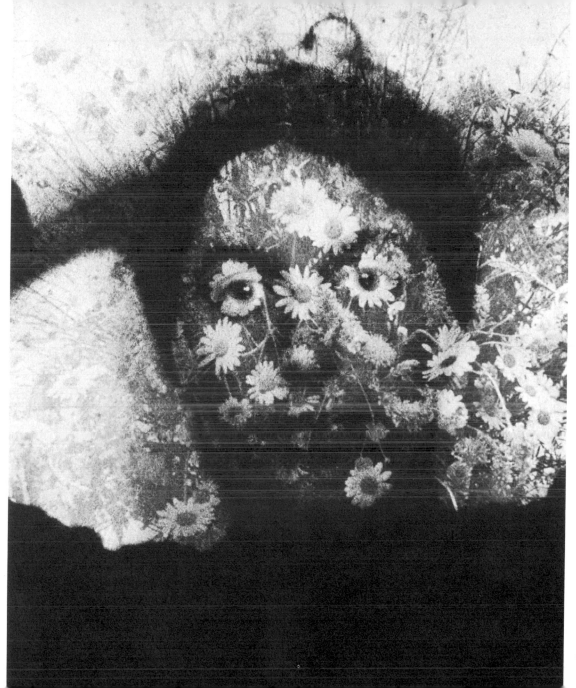

SUZANNE WINTERBERGER

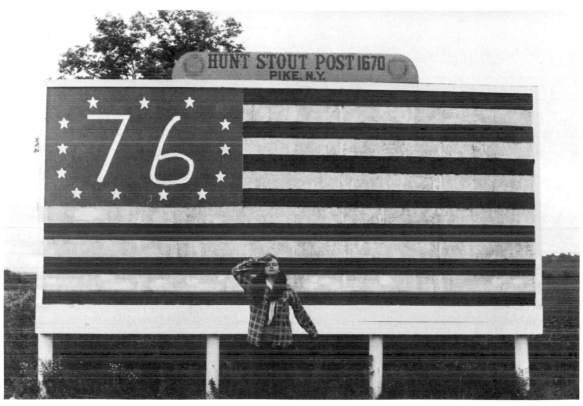

SW

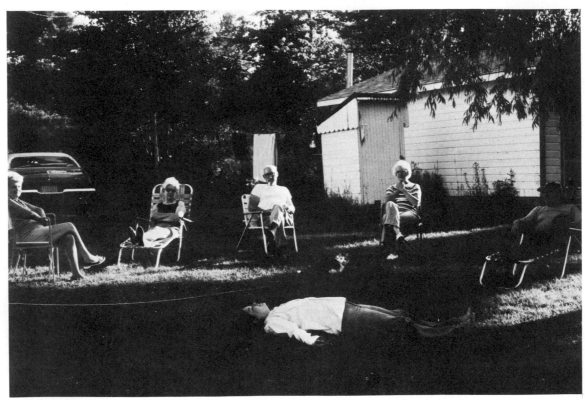

sw

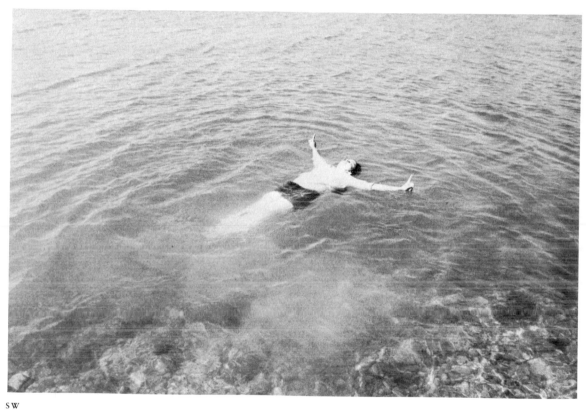

s w

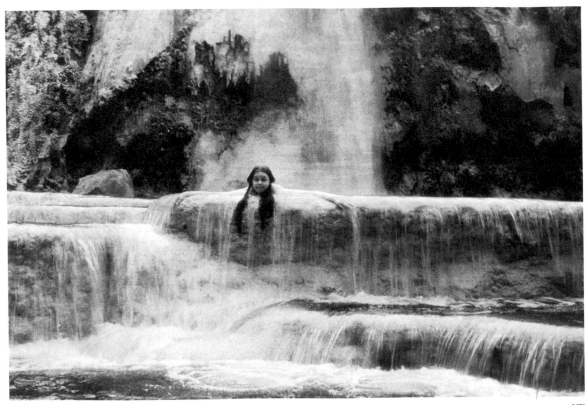

SW

84

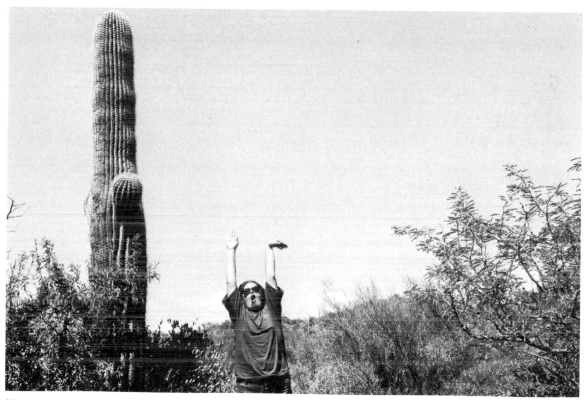

SW

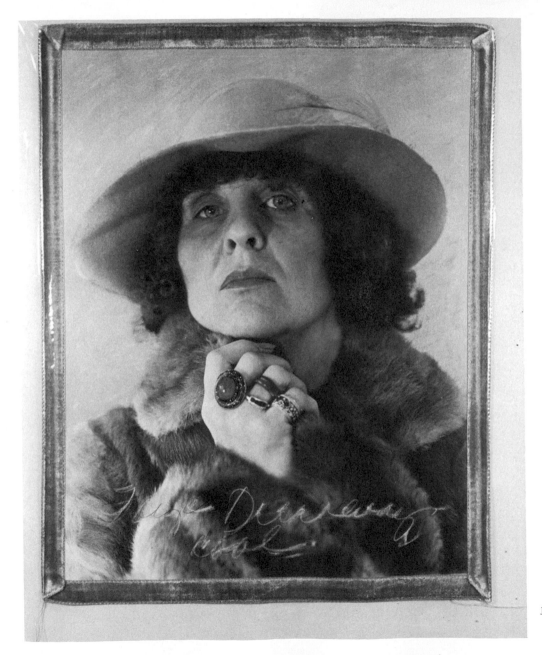

JUDITH GOLDEN

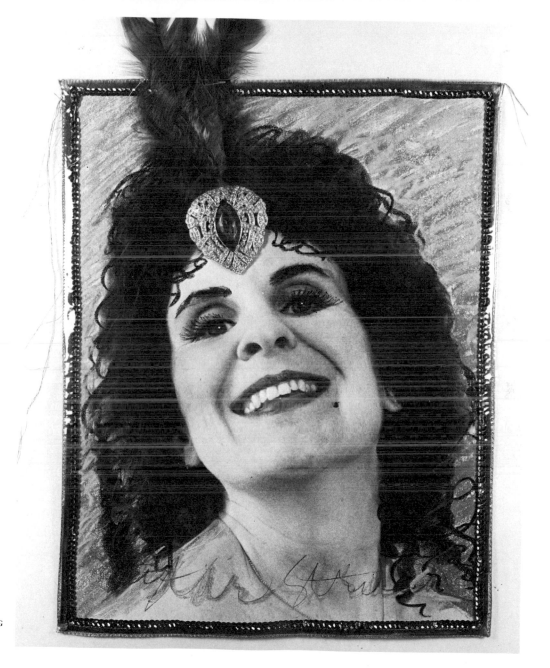

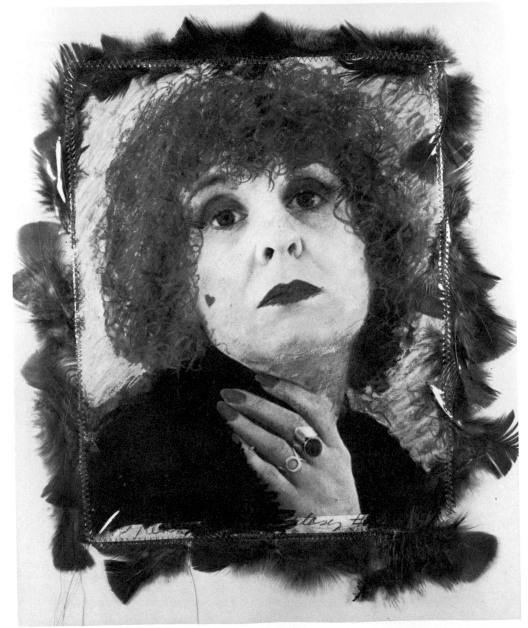

JG

88

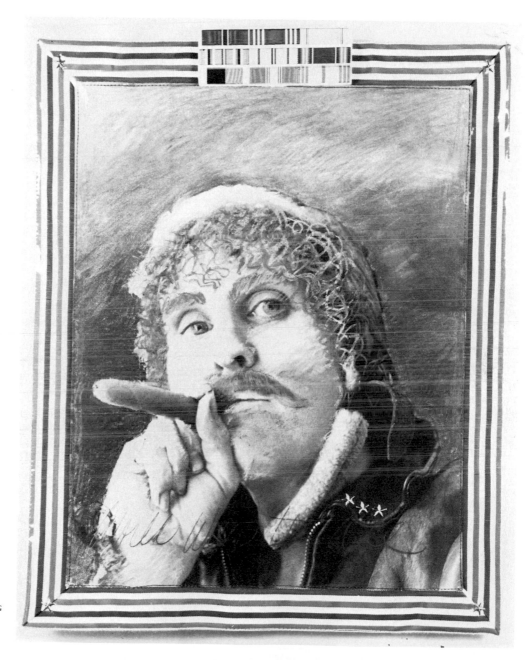

JG

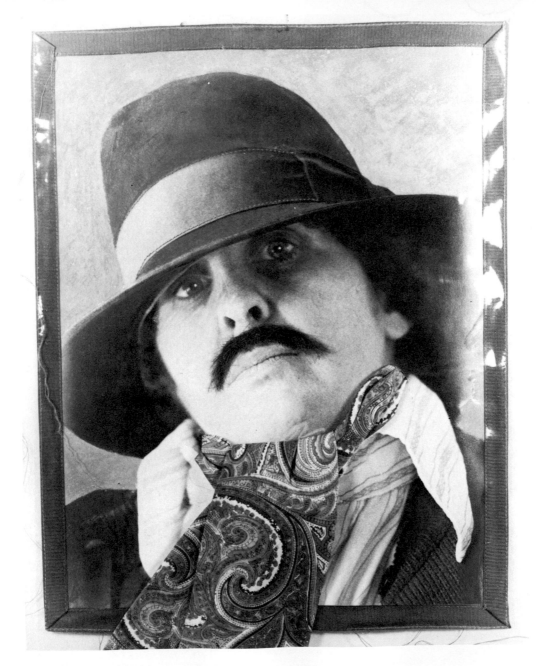

JG

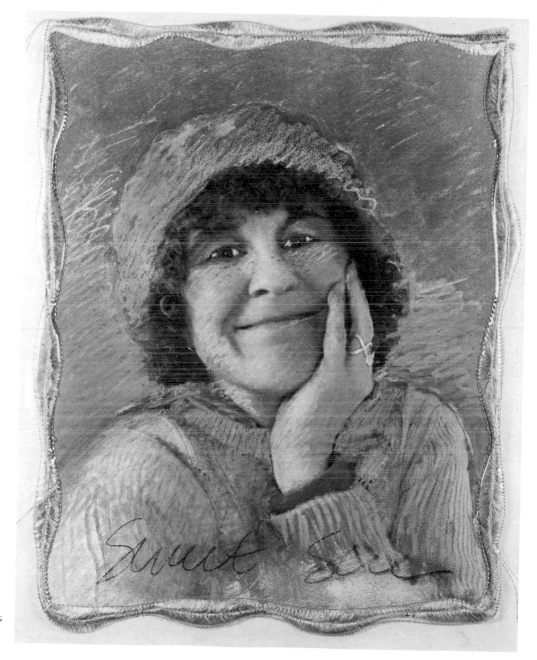

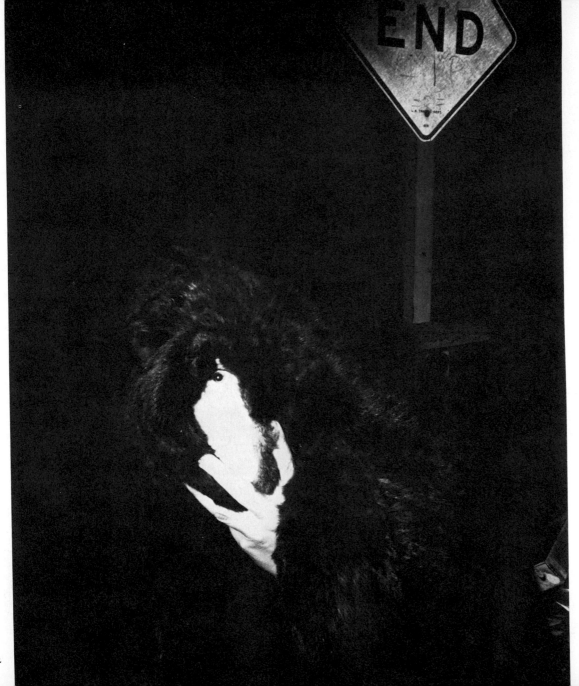

DE ANN JENNINGS

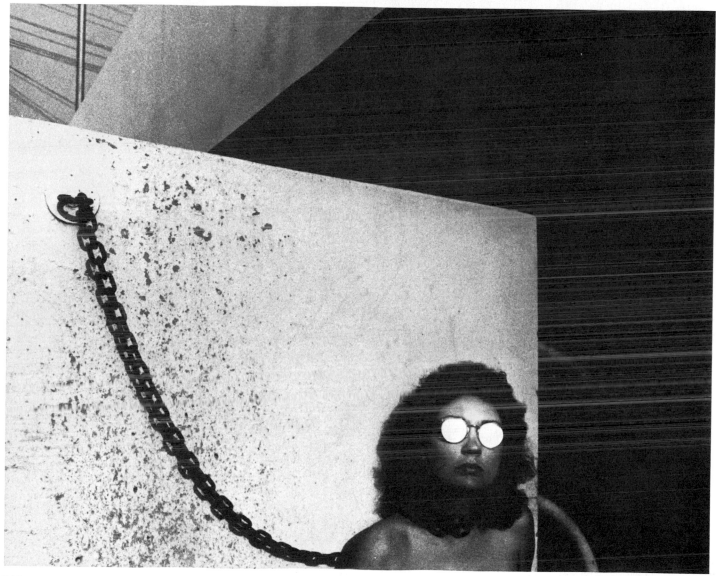

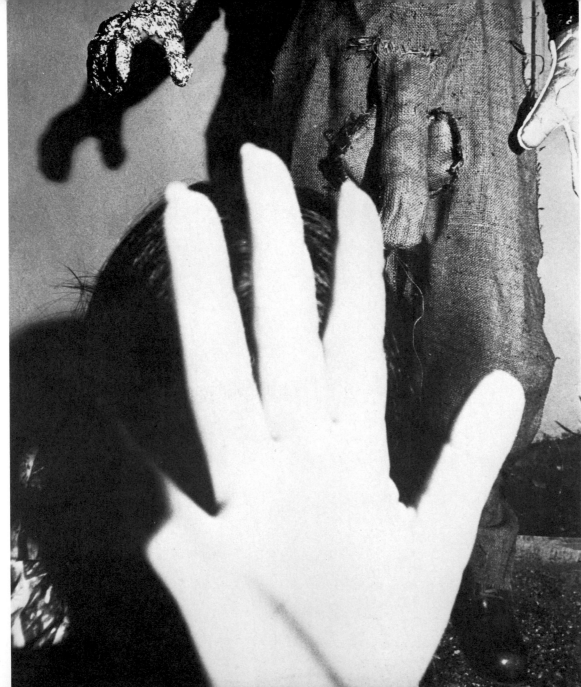

DAJ

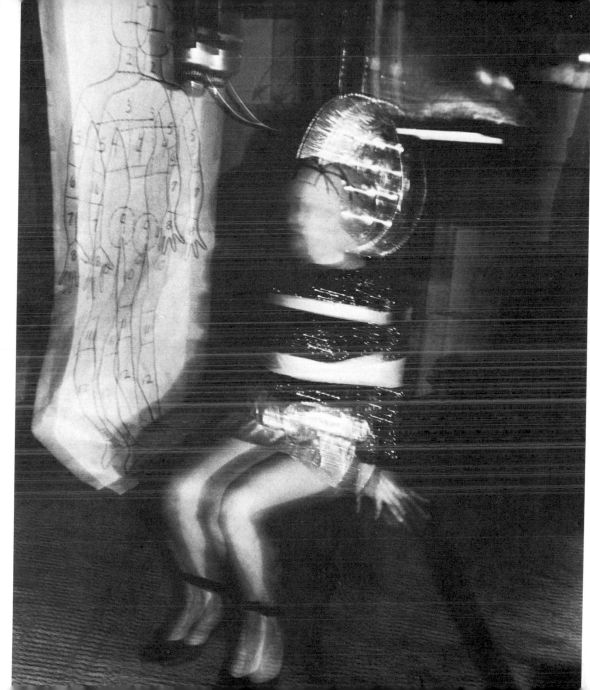

DAJ

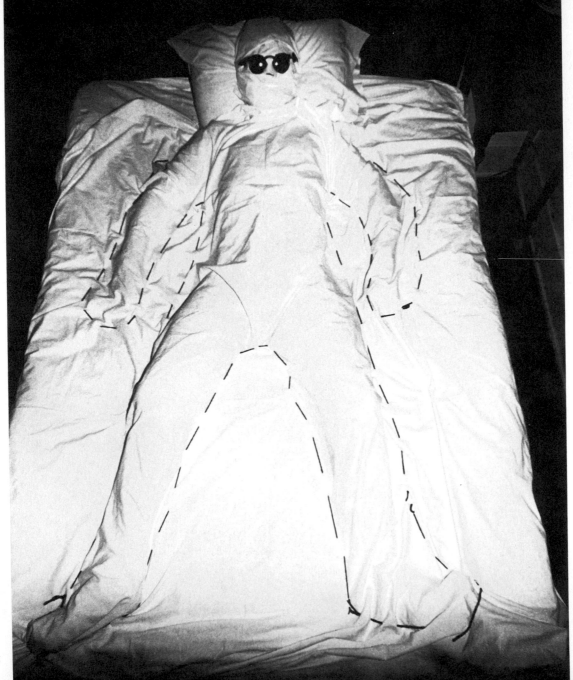

DAJ

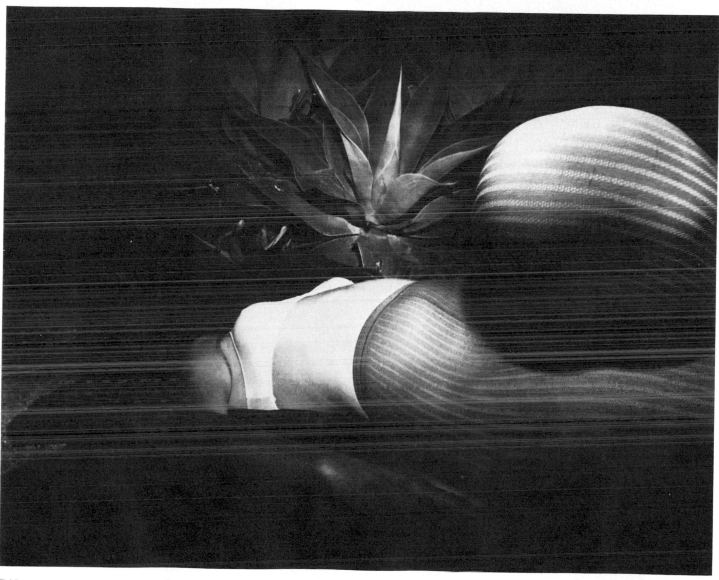

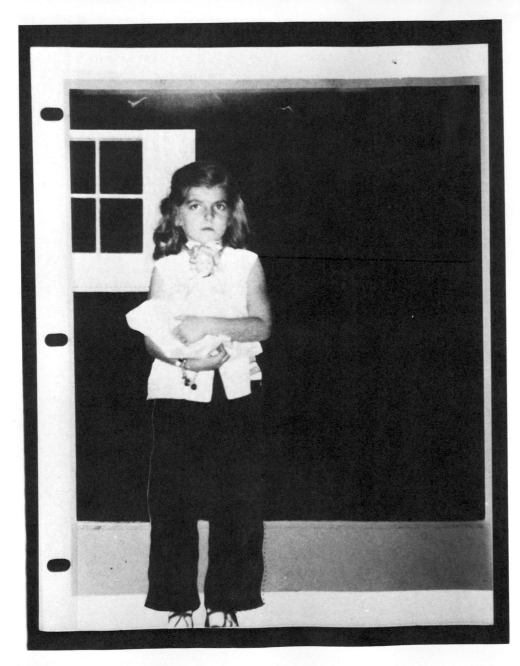

BEA NETTLES

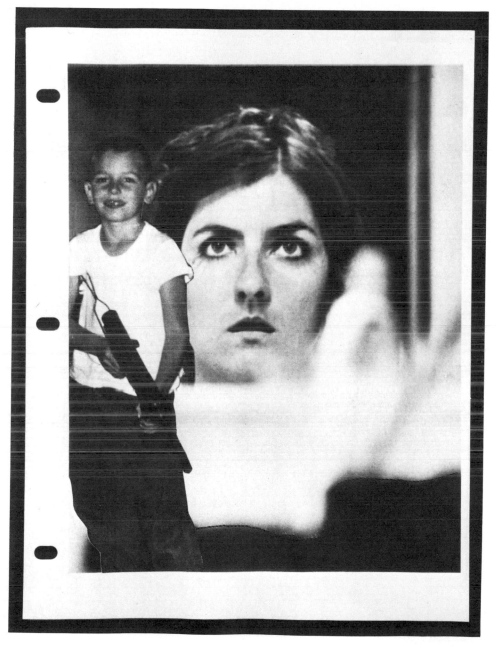

BN

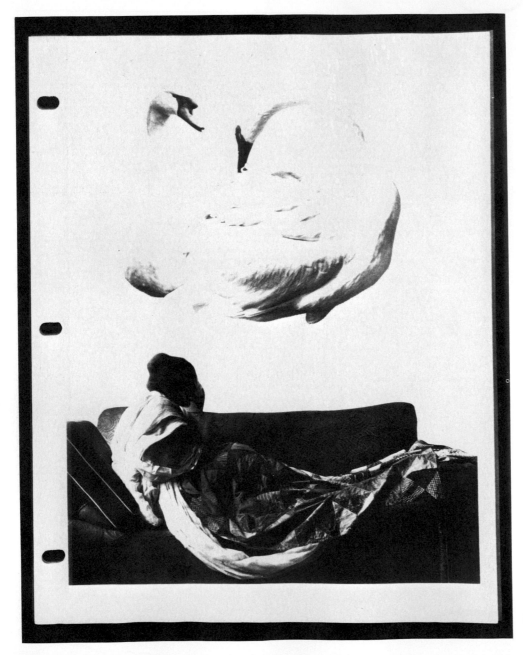

BN

100

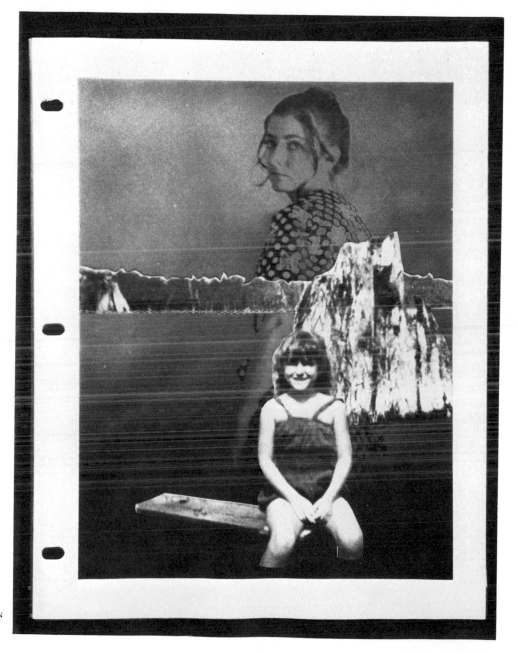

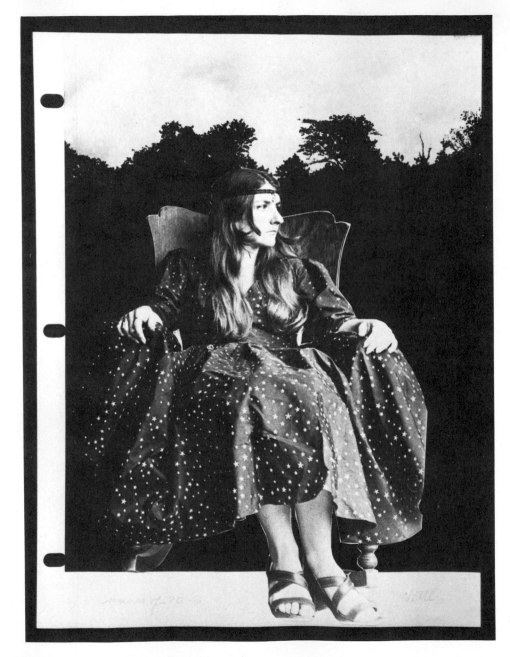

BN

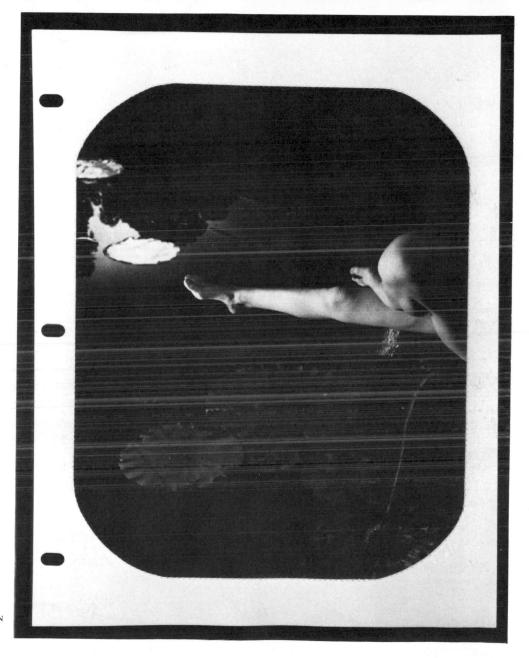

BN

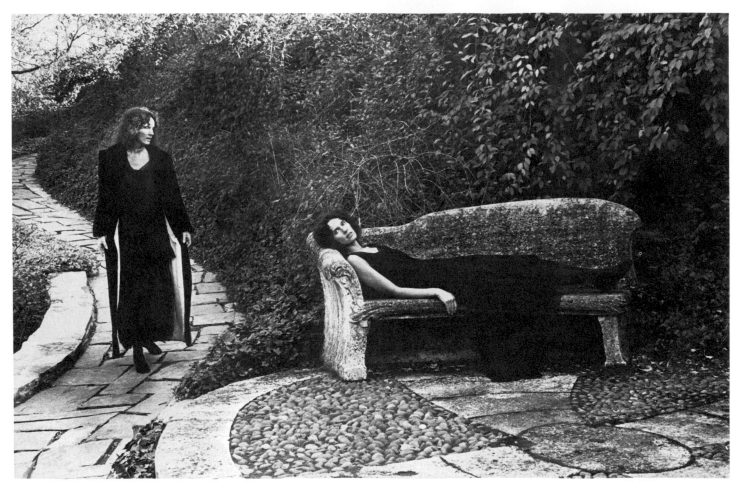

JOYCE TENNESON COHEN

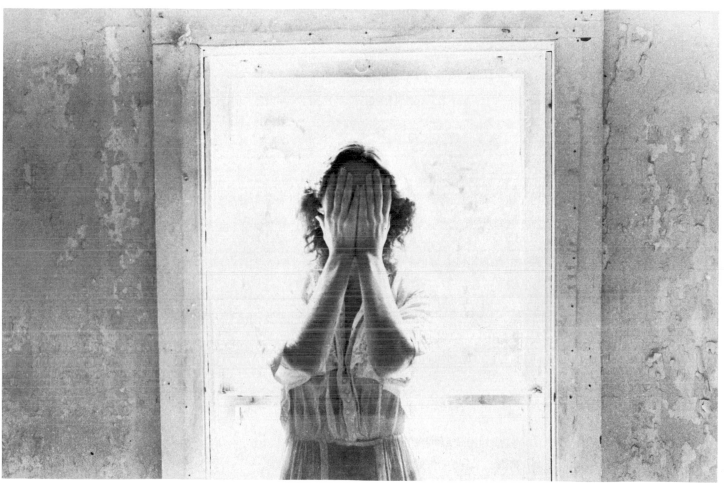

JTC

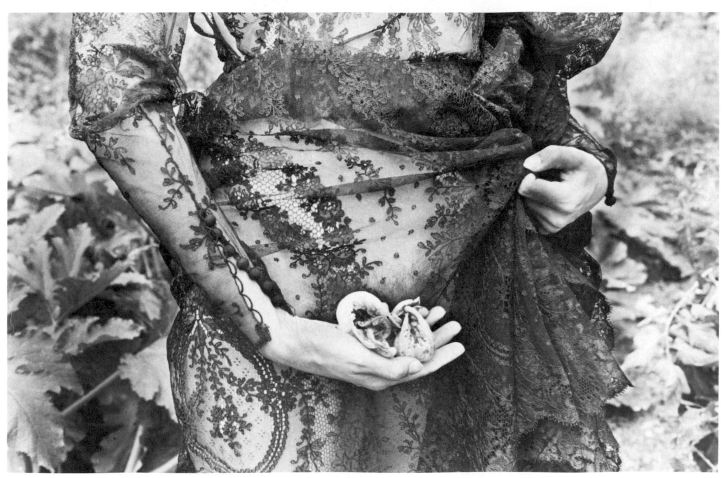

JTC

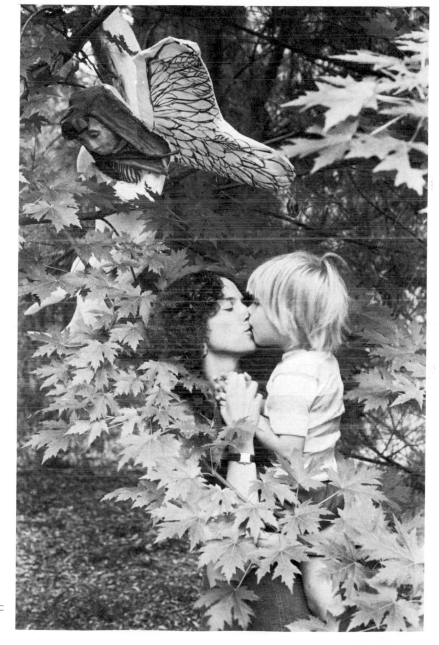

JTC

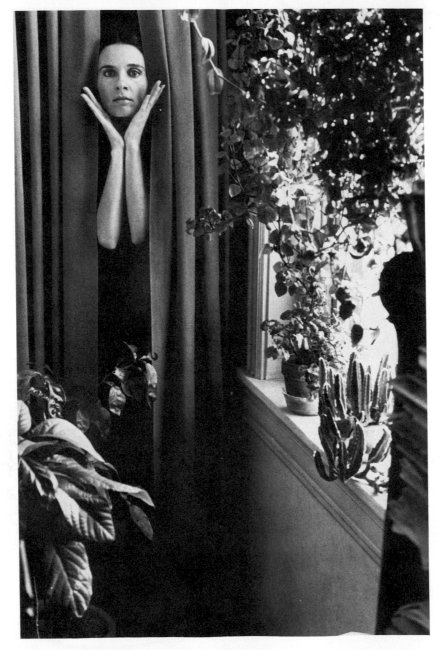

JTC

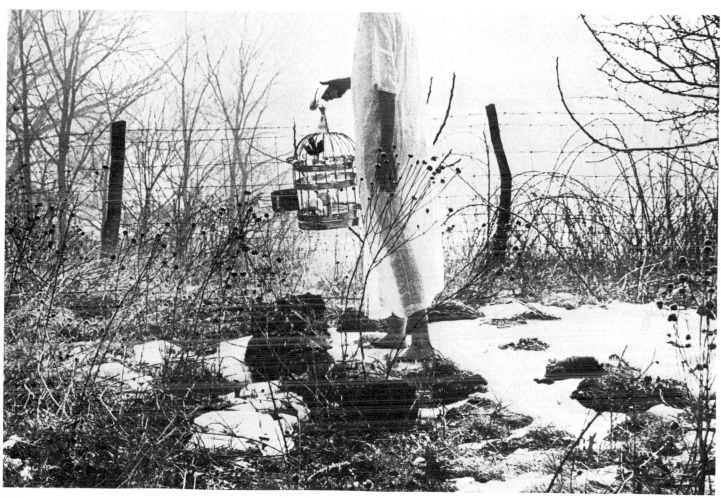

JTC

SELF AS SUBJECT: A Female Language

In autobiography, in outpourings to psychoanalysts, in intimate conversation, in self-portraiture, we reveal ourselves to know ourselves; acts of expression and communication help define us. Intensely individual, such acts yet reveal communal as well as personal realities, locating their performers in historical periods, in specific societies, in gender identities. This group of self-photographs by contemporary American women suggests, therefore—as would a comparable group of autobiographies—a generic female point of view on the current female condition, as well as the feelings, attitudes, and artistic strategies of particular artists. A deep unity subsumes the apparent diversity of these pictures. Speaking for and about themselves, the photographers speak also for and about their sex, suggesting ambiguities of womanhood in a society which has yet to evolve adequate ways of dealing with its female majority, ever more vividly full of power and desire.

Where does the power of women lie? It reveals itself here in acts of incorporation—ironic, loving, aggressive, exploratory—through which photographers convey the complexity of selfhood. Images of a woman with false mustache and man's hat, of a pregnant woman surrounded by and imitating watermelons, of a sleeping woman in conjunction with a sleeping dog, of a grandmother whose shadowy face expresses her granddaughter: these dramatically different visual structures share the implicit assumption that a self makes itself known by adding something. Such an assumption contains many meanings. If a woman offers her own image in the guise of Clark Gable or Muhammad Ali, she ironically suggests her participation in a society which 'sees' male forms of power more readily than female ones. If she photographs

herself in male jockey shorts below naked female breasts, the irony becomes more aggressive: she has made herself visible by preempting a man's intimate apparel, but she reminds her audience also of the prevailing tendency to perceive women as a collection of sexual parts. If she displays her nude body between portraits of her great-great-grandparents, she announces familial continuity but hints familial limitation of personal possibility. The nostalgia implicit in a conjunction between a childhood snapshot and a photograph of the melancholy grown-up woman speaks of the losses inherent in female maturing. Many messages, in short, emerge from a single dominant mode: focus on the peripheral (clothing, setting, companions, paintings, snapshots, posters) as a means of revealing the central.

This technique of incorporation—not manifest in every photograph, but in the vast majority—reiterates a message of female strength. Such a technique in its nature may reveal emptiness or display power; one takes in because one must or because one can. These women *can*: can see themselves in relation to others, to their past selves, their ancestors, their children, their friends, their lovers; and in relation to tree, flower, stone, to typewriter and wallpaper, cleaning rags and baby doll. They dwell in such loving detail on the texture of their surroundings that they virtually animate the inanimate. They re-create the past for themselves and their audience. A photograph of a woman with a china swan, the artist observes, provides an 'explanation of my relationship with my grandmother.' The woman in the picture uses Victorian appurtenances to recapture for herself the lost experience of an ancestor, understanding her own identity as involved with that of her predecessor. A woman's

lower legs merge with tree trunks; a woman photographs contoured rock and calls the result self-portrait; a woman illuminates herself surrounded by the tools of her trade or shows artifacts in place of herself. All declare—and 'explain'—relationship, with the animate or the inanimate world. 'My photographs are made to check and document my relationship to the world as I move through it,' one artist writes. She and the others by their artistic practice assert relationships constituting part of the self.

More than a century and a half ago, John Keats, in letters, struggled to define his own nature as poet. The poetical character, he concluded, 'is not itself—it has no self—it is everything and nothing.' Again, he described a quality that he labeled 'Negative Capability, that is when man is capable of being in uncertainties, Mysteries, doubts, without any irritable reaching after fact & reason.' A self which has no self, a being of uncertainty and mystery, emerges repeatedly from these photographs. Keats's comments suggest that such being belongs not uniquely to the woman but to the artist, to man-as-artist and woman-as-artist. Since the photographers here represented have in common not only their sex but their profession and their moment in history, one must feel wary about concluding that womanhood alone accounts for the predominant stress on contextuality even at the cost of obscuring the physical reality of the individual person. Yet the particularities of the technique differentiate these women's gifts from Keats's: the same kinds of self-consciousness, the same kinds of energy, do not emerge in Keats's work, or in that of Shakespeare, whom Keats declares the great master of 'negative capability.' Many viewers of these photographs find them 'disturbing,' despite the wit and gaiety often apparent in them. The source of the disturbance, I would suggest, is the peculiarly female quality of the pictures, not hard to recognize although difficult to define.

Keats writes with ease and confidence as he describes his own uncertainties. Words like 'ease' do not come readily to mind as one contemplates most of these photographs. On the contrary, these pictures typically insist on the effort of *making* involved in them. A woman depicts emptiness—images of two people now dead framed on the wall over a vacant couch encased in shiny transparent plastic—and calls the result a self-portrait. Another titles her work, 'Husband's Mistress': two lovely blonde women, heads close together, no way of knowing which is which, in the background a shadowy male figure, someone, the photographer explains, who just wandered in. Both pictures embody the mode of incorporation, concentrating on the 'other' to elucidate the self; both emphasize uncertainty, mystery, willingness to deny the self in order to achieve it. And both openly exemplify the disturbing force latent in many of these pictures—partly the disturbing force of ideas (ideas of death and vacancy, and those ideas identified with the self; the idea of a mistress visually indistinguishable from a wife), but also of images (that glassy couch as a necessary visual focus, the obscure male figure which both demands and rejects the viewer's attention). They purposefully deny the possibility of ease, insisting on their own willed clarity of composition, their artificial arrangement of experience. Keats's talk of uncertainty and self-subordination evokes an artistic ideal of natural communion and creative empathy. The deliberated uncertainties of these women's photographs, in contrast, recall Elinor Wylie's lines: 'I, a stranger and afraid / In a world I never made.'

But that association is misleading too; one detects estrangement in the photographs, but fear never dominates them, even in the portfolio labeled *Fears and Phobias*. The artistic act, for these photographers, involves transcendence of the conditions they record. The shadowy male figure in 'Husband's Mistress' draws the eye, but the two females in the image, declared subordinate to a man by the picture's title, assert the drama of their closeness. The force of composition in the picture

of the couch denies the notion that the photographer sees herself as 'empty': she has provided the ordering energy which compels the eye. The group designated *Fears and Phobias* offers symbols of terror and horror—chains, electric chair—but its overwhelming images assert the power of the portrayer's imagination as well as the powerlessness of the portrayed victim. Seeing as women, functioning as artists, these photographers demonstrate that even the relative helplessness of the female condition, converted to object of artistic perception, can provide images of aesthetic control. Of course the forceful artist and the sometimes forceless subject in fact share a single human identity, a paradox central to the effect of many self-portraits here. These women acknowledge the dualities of their social experience in the modes as well as the subjects of their self-portraiture.

The subjects of the photographs—not only the women themselves, but the people and objects with which they surround themselves—supply a set of images which associate themselves readily with the feminine. Linen closet, station wagon, sexy pose—these all participate in the female stereotypes of our society. So does the realm of nature here evoked—the calm and beautiful natural world of tree and flower, stone and animal; no stormy seas or blasted heaths. The photographers allude, satirically or seriously, to conventional feminine symbolism: heart-shaped candy box, flowers, doll baby. The special *use* they make of conventional and unconventional imagery alike, however, reveals their gender more significantly. The paradoxical conversion of social weakness into aesthetic strength shows itself with special intensity in the characteristic reliance on indirection, obliqueness, even subterfuge. These women rarely confront themselves directly: which is to say that they refuse to present themselves in simple ways. The paucity of direct, head-on images emphasizes this. In the typical frontal image, visual context qualifies the impression of directness. We see a woman at a clothesline looking straight at us,

but her image blurs, we see more clearly the towels and shirts that frame her. A despairing figure gazes toward the audience, arms full of cleaning materials; she looks more immediately, however, at the small child in the foreground who wants something from her. A head-on portrait of a woman in bra and panties shows her wearing ankle socks and standing on a mattress, for an effect merging the atmosphere of parody with an impression of spontaneous joy. The viewer's response, in such cases, involves reaction not only to the qualities revealed in face or figure but to images suggesting how and why the person in the photograph herself reacts.

The photographs display diverse modes of indirection. Some rely on mirrors, not only to solve a technical problem of self-portraiture but to suggest distancing or qualification of the direct image. Four exposures of a small looking-glass play image against non-image; six associated mirror-images present a woman acting parts within the frame. The side of a station wagon reflects the photographer's shadowy face and camera. In the wagon one sees an infant, a dog, a woman loaded with groceries. 'I'm looking at the person I thought I'd be,' the photographer comments; she looks also, and allows us to look, at a reminder of the person she is. Others use shadows to evoke the self. A female shadow, for instance, coexists with a real male figure, vivid, bearded; the blatant acknowledgment of insignificance, assuming a quality of self-parody, suggests its opposite.

These women cover their faces with flowers, hats, masks, cloths, dresses. One obscures her face behind a horse, and comments, 'I have since transcended the need to have my physical presence in the photograph.' They show unexpected parts of their bodies—torsos, legs, feet—instead of wholes, or they photograph their panties. They look obliquely at the camera. One elaborates and obscures herself with patterns of light. 'I sometimes try on different possible changes,' she says, 'in a "safe way".' The most triumphant-feeling images show

backs: of a woman contemplating a rising jet-stream (her commentary remarks on the 'joy and exuberance of our [i.e., women's] new freedom'), a woman running through an avenue of trees. A woman compares herself visually to a frog: both joke and symbol; another provides fifteen comic mug-shots, some out of focus, the last one with a large bubble emerging from her mouth, and the sheer fun of the sequence makes it celebration as well as self-mockery. Sometimes the pictures mock the iconography of society, as in images of nude bodies with sexual characteristics emphasized by heavy ink, or a photograph of a female nude folded up in a linen closet. Often they depict or allude to the constant role-playing that marks a woman's life. 'These photographs,' one photographer says, 'gave me the freedom to act out my different selves.' Such freedom belongs specifically to the realm of art. In real life, the world makes conflicting, shifting demands; the woman feels often divided among her possible selves. So these photographers experiment with double exposures, conjunctions of past and present images, split images (half in male, half in female attire), with ways of conveying internal division or complexity. A picture juxtaposes a wall full of prints showing wedding scenes with the figure of the powerful, solitary, female photographer. A self-portrayer sees herself in the guise of movie stars from the past. The photographers find ways to suggest both the liberty and the restrictiveness of their capacity to act parts, to manipulate their own images for public consumption. Photographs and commentary alike expose deviousness and awareness of deviousness, a strong theme of the collection.

Again one may wonder whether such techniques belong more significantly to the woman or to the artist. I would argue that although indirection represents an almost universal artistic device, the degree of reliance and emphasis on it and the nature of the devices used embody something particularly female. *Particularly* female: not necessarily *uniquely* so. To generalize about a group of women does not inevitably differentiate them from men; the effort to achieve clear descriptive differentiation leads to the trap of assuming a greater than necessary dichotomy between male and female artists. Discovering that patterns characteristic of woman photographers, painters, or novelists prevail also in the work of some of their male counterparts does not invalidate the original perception. Men may employ typically female artistic structures; women may employ male ones. A self-portrait, by its very subject matter, obviously reveals the gender of its maker; its way of presenting that subject matter might plausibly suggest what gender *means* to the maker. Certainly the specific kinds of indirection exhibited here allow one to extrapolate a view of how a group of American women understand and use their womanhood; and that view would not be refuted by evidence that some American men understand their manhood in parallel ways.

The language of indirection and incorporation in these photographs bears close analogies to an equivalent language in the imaginative prose of women. 'What can I make that will admit me and encompass me?' wonders the female protagonist of a Margaret Drabble novel. She seeks a verbal structure that will contain without restricting her; an entire novel (*The Waterfall*) records her effort, never altogether successful, to achieve adequate telling of her experience. The problem, as George Eliot put it in *The Mill on the Floss*, is that 'the mysterious complexity of our life is not to be embraced by maxims'—sharp, clear, prescriptive verbal formulations. To find how to embrace that mysterious complexity represents one version of the artist's task; emphatic consciousness of both the mystery and the complexity have preoccupied many women.

One can only speculate about the relation between this special sense of complexity and the air women writers sometimes convey of being at odds with language, an air corresponding to that of photographers who reject the

straightforward image. 'My major fault is the parenthesis,' a female literary critic said to me. Parentheses are devices of inclusion, incorporation, not necessarily faults at all. They provide means of evading the forward movement of a sentence, implying that the shortest way between two points may not be the best one. Men use parentheses too: think of Henry James. Still, they epitomize a female problem and solution.

Metaphoric parentheses abound in this group of women's portraits. False mustache and jockey shorts, images of knees where one expects faces, a figure entangled in tinsel: paraphernalia and disjunctive parts suggest a tentative and fragmented impression of reality, although one possessing mysterious power. These ingenuities of indirection function partly as artistic responses to the need for something new: no one wants to take the same old pictures over again; one must go ever farther afield to achieve freshness. Partly they represent attempts to solve the problems implicit in photographing a self one cannot see. The solutions involve devices and concepts by no means exclusively the possession of women: these photographs belong recognizably to their moment in history by their technical as well as their thematic choices, belong to aesthetic history as well as to women's history. Yet technique and theme, effort at novelty and acceptance of tradition, all allow the viewer to glimpse or imagine a common female sensibility. Uncomfortable with narrow definition, this sensibility strives for multiplicity. In *The Princess of Cleves*, a seventeenth-century French novel by Mme. de Lafayette, occurs a scene in which a man looks at another man looking at a woman looking at a miniature of the man watching her. This kind of layered perspective represents the ultimate achievement of the art of parentheses. Its equivalent among the photographs is the picture of a sleeping young woman framed by the partial bodies of three other women descending stairs: the meaning, inher-

ent in the relationship, conveys itself through indirection.

An aging woman photographs her wrinkled upper back, knobby hands locked behind her neck, twisted shoulder strap intersecting flesh. She concentrates on a part, not the whole of her physical self, and on a part usually considered unrevealing. The audience can hardly fail to be conscious of the refusal implicit in offering a back view under the title, 'Considering Myself.' This refusal, however, has its own rhetoric of positive meaning. It speaks of affirmation, endurance, strength. A ponytail tied with a wide ribbon partly covers the arthritic hands, testifying to the survival of attractiveness and of concern with it, and to the relation between beauty and strength. The formal eloquence of the composition reiterates the same relationship. By a strategy of deviousness, the photographer has conveyed her rich sense of self and her transcendence of conventional means of expressing it. The meaning of the portrait inheres in its rejection of poses, values, strategies as well as in what it accepts: the parenthetical (surely the back of the neck epitomizes the parenthesis) becomes crucial.

Words like *indirection, evasiveness, deviousness*, even *parenthetical*, may suggest weakness and inadequacy—a fact reflecting limitations of vocabulary, not of womanhood. The portraits themselves suggest nothing of the sort. They express instead the triumph of indirection, a mode of enlargement and inclusion that implies a refusal to rest on limiting definition, awareness of precisely what such definition involves. This group of photographs declares a female consciousness sensitive to the restrictions of society, capable of surmounting them by knowing them inclusively. The pictures re-create a collective icon of woman as a being of power emerging from mystery.

—PATRICIA MEYER SPACKS
Professor of English, Wellesley College
Author of The Female Imagination

NOTES BY THE PHOTOGRAPHERS

arranged alphabetically

45 45

CATHERINE GARDINER ALLPORT

The images did not begin as an idea.

When I was three I had a dream that I flew into the kitchen where Miss Doan, our nurse, was making deviled eggs. She saw me, but didn't act surprised. That afternoon she died.

The white garment a friend brought from Africa. I never wore it, but I never threw it away.

I want to go beyond, to defy limitations.

It was a warm spring day. I was in love; my friend and I were on the roof playing music, a drum and a saxophone.

The light was perfect. It came to me in a flash.

Catherine Gardiner Allport received her B.A. from Stanford and did some graduate work in film and anthropology. She has taught photography to children and to incarcerated women. She is now working as part of the CETA Artist Project in New York City, teaching workshops in prisons, nursing homes, and hospitals. *New York, New York*

JUNE ASCHENBACH

I would prefer to be identified not by where I've been or what I've done but by who I am and what I am doing.

I am a traveler, an explorer, a discoverer, a pilgrim, a pioneer—in unexplored, uncharted, unmapped Terra Incognita. My work is about journeys to inner and outer spaces of the unknown. In this space credentials and ego-statistics seem relatively

34 unimportant. *Winooski, Vermont*

42

LINDA BENEDICT-JONES

I was given these panties by a friend, Ines Barahona, and always feel secretly lighthearted wearing them. I'd tried photographing them in other ways, but nothing worked quite as well as when I was in them. I like to see people smile when they see this picture.

Linda Benedict-Jones has lived and worked in Europe for the past eight years. She received a diploma from the New England School of Photography in 1971 and later studied with Charles Harbutt, Ralph Gibson, and Eva Rubenstein in Arles, France. Her work has been exhibited widely in London, Paris, Milan, Amsterdam, and Lisbon as well as at the Madison Art Center, Wisconsin. She received a grant from the Arts Council, Great Britain, in 1977. *London, England*

47

EILEEN BERGER

This self-portrait was made at a period in my life when I was very consciously struggling with the issue of 'identity.' At this time I could only perceive of myself as a series of sometimes-related fragments or roles, i.e. female, wife, mother, daughter, emerging adult, teacher, artist, etc. Although my sense of self was limited by a very clear-cut feeling of separations, I nevertheless believed that if I continued this exploration, something more unified and synthesized would eventually emerge. This particular image came out of that period of picture-making, and dealt with investigating a sexual identity which was filled with contradictory factors.

Eileen Berger received an M.F.A. at the Tyler School of Art, Temple University, and currently teaches at Moore College of Art. She has had numerous exhibitions, including shows at the Steiglitz Gallery in New York City, Philadelphia College of Art, Boston University, and Philadelphia Museum of Art. Her work has been published extensively. *Wyndmoor, Pennsylvania*

52 53

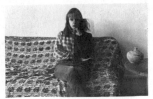

28

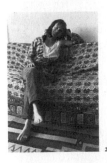

28

FRIEDL BONDY

In 1972 I started a series, the one-year self-portrait 'mirror,' because I felt the need to do something of consequence. Missing portraits are due to feelings of aggression against myself, indifference, or forgetting. Before and during this one-year project I had a certain narcissistic vision of myself, which the finished one-year self-portrait forced me to change.

I also found out that a photographic portrait consisting of several hundred shots has more density and is of more informational value than a single photograph.

Photography has become a tool for me. The facility of the medium, the relative easiness of producing hundreds of images of one person in a short space of time, makes photography a perfect device to help analyze myself and others.

From March 1977 to March 1978 I completed another one-year self-portrait which shows my different attitudes toward photography and myself. I intend to continue doing one-year self-portraits in five-year intervals until the end of my life.

Friedl Bondy was born in London in 1946 and attended school in Berlin and Vienna. She has worked as a free-lance photographer. In 1971 she started to produce pin-up-like auto-portraits with the use of mirrors. Her work has been exhibited and published, and since 1975 she has given many lectures at universities and art schools throughout the United States. *Vienna, Austria*

GILLIAN BROWN

At the time these photos were made my world view was becoming increasingly solipsistic; I was feeling that I was the sole fabricator of my reality. This awareness was apparent in many of my photos which were always manipulated and directorial, but here the awareness was aimed at my own image. Egos and alter-egos were freely superimposed and made to coexist.

Gillian Brown received her A.B. from Brown University in 1973 and her M.A.E. from the Rhode Island School of Design in 1977; she is now an M.F.A. candidate at U.C.L.A. From 1974 to 1977 she was an art instructor at The Mountain School in Vershire, Vermont. Her photographs have been exhibited at Goddard College, San Francisco Camerawork, Purchase Prize Fleming Museum, Walker Gallery, Central Washington State College, and Brown University. *Gardner, Massachusetts*

BOBBI CARREY

74	*Legacies*	77	*Weight Watcher*
75	*Terra Firma*	78	*Solitary Confinement*
76	*Site Unseen*	79	*Photosynthesis*

When I look back over the self-portraits I did several years ago it scares me a little—I see a strong piece of myself that formerly was under my control, but which now seems to have taken on a life of its own.

SUSAN BRANSFIELD

What is most important about this image of mine is that it was on a spring day and that it was a spring day first.

This fall I began my first year at Hampshire College, where I was lucky enough to be taught by Bill Arnold.

From the first and through the years, Marty Madigan, a very close friend, has taught me about making photographs, blueprints, and pinholes, but most of all about trees and hearts. *Wilmette, Illinois*

5

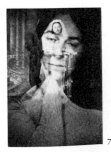

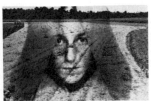

74 75

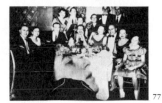

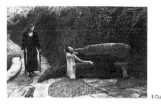

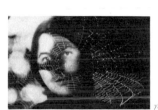

The content of my work changes as the important issues I am concerned with do. However, the images generally fall into three broad categories: (1) reflections on the past (combining past and present pictures), (2) fantasies I am conflicted about, and (3) ambiguous, intangible feelings I'm only vaguely conscious of at the moment.

Bobbi Carrey has taught at Harvard University, University of Iowa, and Antioch College. Her work has been exhibited in over twenty-eight shows including one-person shows at Neikrug Galleries, New York; the Photographer's Gallery, London; and the Panopticon Gallery, Boston. She has also published widely in books and magazines including *Collecting Photographs: A Guide to the New Art Boom, The Photographers' Choice, Women of Photography, Ms., Boston Globe, Exposure,* and *Popular Photography Annual. Cambridge, Massachusetts*

KAREN CLEMENS

Portrait to Myself, Spring 1975

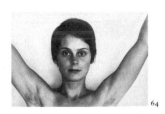

Sometimes I wish I could be this person. I spend a lot of time pretending that I'm not. I get no help from my friends—nobody will let me hide in their house.

Karen Clemens is a free-lance photographer and businesswoman from Woodbridge, Connecticut. She graduated from the University of Illinois in 1970 and then worked for several years as a news reporter and feature writer for the Post Publishing Company in Connecticut. Largely self-taught in photography, she has attended workshops at Archetype, New Haven; Manhattanville College,

Purchase, New York; and The New School, New York City. She has had two one-woman shows in Connecticut and is currently working on a project involving women at a midwestern crisis center. *Woodbridge, Connecticut*

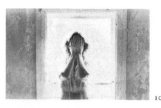

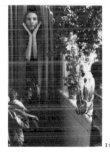

JOYCE TENNESON COHEN

Most of my photographs derive from my own fantasies and unconscious life. These images often reflect varying levels of meaning. They contain a mix of the metaphorical and the symbolic, and at times may be enigmatic or elusive. If they succeed, they provide the viewer with a pathway along which personal experiences, impressions, dreams, and sensitivities can be thought about in a different manner.

Joyce Tenneson Cohen is a photographer, writer, editor, and teacher. She holds

an interdisciplinary Ph.D. degree in art and human development and has a special interest in the way art has been used by the artist (photographer, writer, painter, etc.) to further understanding of the self or the human condition. She is a photo editor and critic for the *Washington Review of the Arts*, and has lectured at numerous colleges and universities throughout the country. Her work has been published and exhibited extensively both in the United States and Europe. *Washington, D. C.*

regional, national, and international invitational exhibitions including the New Orleans Artist's Biennial, Women Look at Women, and a United States Information Agency circulating exhibition in South America. She has conducted several workshops and lectures and has had portfolios published in *Petersen's Photographic Magazine*, January 1976, and *The Humanist Educator*, 1976. *Tampa, Florida*

HONOR CONKLIN
Anna's Swan

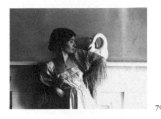

This self-portrait was an explanation of my relationship with my grandmother, Anna Maine Conklin. Never having known her, I have tried to learn about her through interviews and old photographs. This photograph was an added tool in gaining insight into the era in which she lived, that of the turn of the century, with its wealth, elegance, and culture. I was examining our similarities and our differences—what has been handed down and what perhaps should be discarded.

Honor Conklin has exhibited for the past seven years in group shows at the State University of New York at Binghamton; Roberson Center, Binghamton; and the Everson Museum, Syracuse. *Binghamton, New York*

JOYCE CULVER
Self-Portrait with Judy

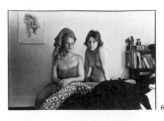

At the time I made the photograph, Judy and I had known each other only a short time yet we both seemed to know everything about one another. The total honesty I feel shows in my nudity. There is a certain ease and closeness between us as friends that visually describes the feelings I had about myself at the time.

Joyce Culver received her undergraduate degree in art education from the State University College at Buffalo and her M.F.A. from Rochester Institute of Technology. She has taught public high school in Pittsford, New York, and is currently a free-lance artist and part-time instructor of color photography at Rochester Institute of Technology. Her work has been exhibited widely and is part of the permanent collection of the International Museum of Photography at the George Eastman House. *Rochester, New York*

SUZANNE CAMP CROSBY
Woman at Clothesline

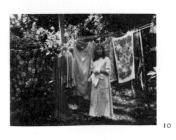

My photographs are spontaneous and intuitive responses to subjects which communicate significant and sometimes mysterious qualities to me. I believe that the photograph can be a means of awakening personal sensibilities and awarenesses of the things that are most meaningful and important. Ideally the photographic image then becomes a means of sharing individual perception with others.

Suzanne Camp Crosby received her education at the University of Florida, Gainesville (B.F.A., 1970) and the University of South Florida, Tampa (M.F.A., 1976). She served as a professional photographer on the Educational Resources staff at USF from 1972 until 1977. She is a member of the Art Faculty at Hillsborough Community College in Tampa and was a visiting artist/instructor at Florida Technological University, Orlando, in 1977. She has been represented in

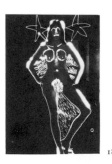 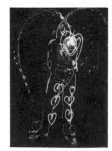

TESSIE DANIELS

These photographs are from a series of light drawings done one winter, and were a way for me to explore some of the ideas I had about myself.

Tessie Daniels is a young photographer who grew up in South America. She moved to Chicago, Illinois, in 1973 to pursue her photographic studies at the University of Illinois. *Chicago, Illinois*

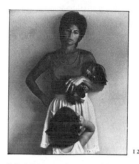

ETHEL DIAMOND

Self-portrait as the mother of two small children

This image occurred to me when I was in the middle of cleaning. I felt so overwhelmed by the endless drudgery of housework; I thought if I just stood in front of the camera as I felt then, this feeling might show through. As I was about to take this self-portrait, my son walked up to me, demanding my attention.

12

Ethel Diamond received her B.A. from Barnard College in 1966 and attended New York University Law School 1966–1969. *Fanwood, New Jersey*

ELSA DORFMAN

A note on 'My Thirty-ninth Birthday,' April 26, 1976

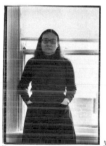

My thirty-ninth birthday – Dorfman 31

Since I always take pictures to commemorate occasions, to look at myself on personally important days, it was inevitable that I would take my picture on my birthday. I was in a very nice place in my head then, spring, 1976. My photographic work was coming along nicely and I had the time to work. I was living up the street on Flagg Street with Harvey Silverglate, and working during the day at my house, number 19 Flagg Street. It worked well, but it didn't box me in, and I felt comfortable. So, that's where I was in my head. I took a lot of pictures that day in my kitchen, which is where I always worked editing manuscripts. They show the bulletin board with a million notices and postcards and my calendar on it. The wide-angle lens takes in the whole kitchen — it's not that big a room. Then I changed the lens to work more narrowly, to really nail myself, to see exactly *who* I was at thirty-nine. I went into the living room. I wanted something less distracting than was possible in the kitchen, something more naked, something bearing down on myself. It turns out that this picture of me on April 26, 1976, is my last self-portrait before I became pregnant. Nine months later, Isaac Dorfman Silverglate was born. The pictures in the kitchen are nice, and I like them a lot — for their information and the memorabilia on my walls. But this is the picture I think of as myself *before* all the responsibility of motherhood.

Elsa Dorfman was born in Cambridge, Massachusetts, in 1937 and still lives there.

Her book, *Elsa's Housebook — A Woman's Photojournal*, was published by David R. Godine in 1974. Every Christmas, she sells her photographs in a shopping cart in Harvard Square at bargain prices. She is a non-resident tutor at Mather House, Harvard University, and is affiliated with The Witkin Gallery in New York City. *Cambridge, Massachusetts*

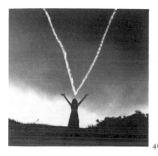

46

72

MARY BETH EDELSON

What I am most concerned with at this moment is spirituality as it manifests itself in our bodies/minds and how this effects how we see/feel about our being, and a feminist awakening to the *greater self* as female. The first self-portraits I made as a young woman had to do with looking at myself and saying 'who are you?' Now that I have some clues to answer that question, I concern myself with 'who are we?'

Woman Rising symbolizes the joy and exuberance of our new freedom as well as making a political statement for women that says *I am,* and *I am large,* and *I am my body,* and *I am not going away.*

Arbor: Light Feet is a part of a series of photographs taken of my body wrapped in transparent loose cloth — walking, running, and disappearing. I was the fire spirit with light feet that both gives and takes away, mourns and celebrates, and leaves you wondering.

Mary Beth Edelson has had thirteen solo exhibitions and over twenty-five group shows. Her work has been written about in over forty publications including *Arts Magazine, Village Voice, Art in America, Art News, Artforum, Heresies,* and *Chrysalis.* She lectures at conferences, colleges, and universities throughout the country. *New York, New York*

SUZANNE EMOND

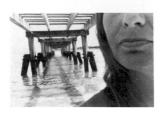

It was a particularly warm, balmy spring morning when my son and I went down to the barn to take photographs. I think that this photograph conveys the sense of relaxation and playfulness that we felt that morning.

My name is Suzanne Emond. I am a thirty-six-year-old mother of two children. I took up photography five years ago because I was restless. I enrolled in photography evening courses and gradually became so involved that I am now a third-year student in a four-year photography program at Ryerson Polytechnical Institute here in Toronto. *Toronto. Canada*

13

CHRIS ENOS

I probably had nothing in mind as usual, just looking for good images. I photographed myself because I was the only person I knew in Boston at the time.

7

Chris Enos received an M.F.A. in photography in 1971 from San Francisco Art Institute. She is currently director and president of the Photographic Resource Center, Boston. She has taught at New England School of Photography, Harvard University, Goddard College, Boston University, Hampshire College, and University of California. Her work has been exhibited extensively, nationally and internationally, and is part of the permanent collection of the Bibliothèque Nationale, San Francisco Art Museum, Museum of Modern Art in Boston, and the Fogg Museum of Art. *Boston, Massachusetts*

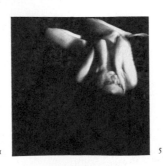

51 51

ANNE-CATHERINE FALLEN

I was living in an unfinished attic. Every morning I would awaken to the words 'This side toward living space' neatly printed on the foil insulation. (Sometimes it was reassuring to wake up knowing I was on the right side.) I began to study myself in that unusual space and light— the emotional anguish and creative frustrations of that transitional time were mirrored in the group of images I entitled *Living Space*.

Anne-Catherine Fallen recently moved to the Washington, D.C., area from Rochester, New York, where she was involved with the Visual Studies Workshop. Her work has included photographs and one-of-a-kind books of self-portraits which utilize various printmaking processes. *Arlington, Virginia*

 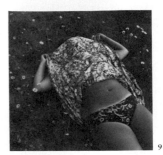

8 9

SANDI FELLMAN

These self-portraits were the beginning of a very personal body of photographs entitled *Secrets*. The format of my more recent work has changed, yet I continue to explore related ideas. I consider this work a sharing of very 'secret' private thoughts and sensations. These early images are very much about myself; however, I have since transcended the need to have my physical presence in the photograph. My interest in the tactile and sensuous continues to be paramount in my work.

Sandi Fellman was born January 24, 1952. She received her M.F.A. from the University of Wisconsin, Madison, in 1976. In 1974 she founded the Exposure Press which produces handmade limited edition books, and which has published one mass-market book entitled *Trick or Treat*. She has been teaching photography at Bemidji State University for the past two years, and received a Minnesota State Arts Board Project Grant in 1978. She is currently involved in a long-term research project with Shelley Rice on contemporary women's photography. In the last three years, she has exhibited in over fifty one-person and group exhibitions, and is represented in twelve major photography collections across the country. *Bemidji, Minnesota*

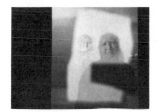

ELAINE FISHER

A while ago I made plans to visit my grandmother, whom I had not seen for several years. She had raised me and I think of her as my mother. And although I was a woman in my mid-thirties, it was

31

with a very young excitement that I looked forward to seeing her.

These feelings provoked me to make this photograph. I decided to use two negatives, one of her face, and one of diffused environmental shapes which seemed sad, fading, and as if they were some sort of barrier. This process felt similar to the remembering of a dream. I printed her face twice. Dreams have a way of repeating important images. This duplication also created a sense of moving in space, which seemed emotionally correct—she was coming towards (or leaving?) me in an indistinct atmosphere. I also printed in the wide black panels on both sides to show the different worlds, the difficulty of reaching each other over so much space and time.

If I had felt young in my enthusiasm to see her again, I also felt young as I watched the print emerge. It was as if I were a child again, and wanted her to change the darkness I was in. It was as if we were the same person, the way very young children make little distinction between their mother's identity and their own. It became a self-portrait.

Four days before I was to surprise her with my visit, she died.

Elaine Fisher was born in New Jersey in 1939. In 1961 she received her B.F.A. from Carnegie Mellon University. In 1972 she was awarded a National Endowment for the Arts Fellowship in Photography, and also was awarded a First Prize in Photovision '72 of New England Photographers. She has been included in *Who's Who of American Women*, *Dictionary of International Biography*, and *Who's Who in American Art*, and her photographs have appeared in *Aperture* and *Women See Women*. She has exhibited her photographs in museums, galleries and at universities in twelve states. Currently, she is an associate professor at Southeastern Massachusetts University. *Cambridge, Massachusetts*

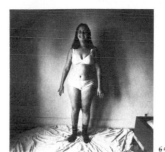

PHYLLIS GALEMBO

This image, like most of my other photographic portraits, involves humor. There is nothing very unusual about it; it was taken in my bedroom very quickly. I enjoy photographing people as they take a private part of their life and make it public.

65

Phyllis Galembo is currently teaching photography at the State University of New York in Oswego. Her recent exhibits include one-woman shows at the Rhode Island School of Design and the University of Wisconsin, Madison. Her photographs have also been included in group exhibits at New Photographics, Washington, the Magic Silver Show, and Friends of Photography, Carmel, California. In addition to working in photography and etching, she has taught children's photography courses for several years. *Oswego, New York*

JUDITH GOLDEN

Chameleon Series
86 *Faye Dunaway, cool . . .*
87 *Star Struck*
88 *Redhead Fantasy*
89 *World War II Ace*
90 *Frankly, My Dear, I Don't Give a Damn*
91 *Sweet Sue*

For the past several years I have been dealing with self-portrait fantasies. The work involves idealized symbol and mask, illusion and reality. A continual exploration of self, society, roles and issues, my work is a personal and hopefully universal glimpse of women conditioned by contemporary American culture.

The *Chameleon Series* deals specifically with roles we all play, es-

86

87

88

89

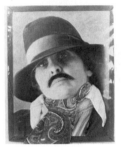
90

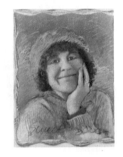
91

pecially changes in the self relative to environment and relationships. This work grows out of my experiences and need to express visually the thoughts and struggles toward greater self-understanding and moving away from the conditioning of my American middle-class training. The definition of 'chameleon' is 'remarkable for changes of color according to mood or surrounding condition,' which directly states my area of exploration.

The one-to-one scale of the photographs questions further the real and the illusion of reality. Color is of extreme importance: I use hand-applied color in order to totally control the depth and saturation of the hue. These pieces are sewn in plastic and framed with trim to further emphasize the training of my femaleness and American packaging.

Judith Golden received a B.F.A. from the Art Institute of Chicago and an M.F.A. from the University of California, where she currently teaches. Her work has been exhibited widely and published in *Art in America*, *Art Week*, and the *1978 Time-Life Photography Annual*. Her work is in the collection of the Fogg Museum of Art, the Oakland Museum, the Art Institute of Chicago, and the University of New Mexico. *Inglewood, California*

ABIGAIL HEYMAN

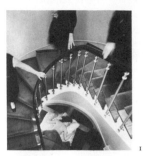
I

The following is an excerpt from the introduction to *Growing up female: a personal photo-journal*.

'I looked at people and events long before I owned a camera, more as a silent observer than a participant, sensing this was a woman's place. It is no longer my place as a woman, but it remains my style as a photographer.

'I have been a girl child and, in my expectations, a mother. I have tried to be prettier than I am. I have been treated as a sex object, and at times I have encouraged that. I have been married and have seen my husband's work as more important than my own, his decisions sounder than my own. And I have been divorced. I have been a premedical student and did not go on to medical school because I could not take my education seriously just as no one around me would. And so, instead, I have been a salesgirl, and a receptionist, and a full-time housewife. I have thought housewives and mothers did nothing of importance. I have disrespected all women but the rare woman who did what men did. I have disregarded women, as I disregarded myself. And I have changed. I have faced the conflicts inherent in growing up female, as I am now facing the conflicts in trying to change. This is where I come from; this is what I want to document.'

Since 1967 Abigail Heyman has been photographing people and their relationships to their environment and to each other. Her photographs have appeared in major American and European publications and shows. She photographed and wrote *Growing up female: a personal photo-journal*, published by Holt, Rinehart & Winston. *New York, New York*

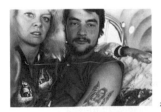
22

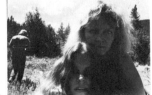
23

CHERIE HISER

Untitled
I don't like to talk too much about this photograph because it is a strong fantasy photo for me; I was creating a souvenir of another

reality. I will say we were in my 1941 Chevy 'Maybelline' Aspen.

Husband's Mistress
This clearly shows what surprises can occur when I'm holding my camera out and I'm not looking through the viewfinder. I wanted to photograph David's mistress for that feeling of 'fantasy closeness' and as I did, a male figure, a symbol for why she and I were together, walked into or out of the frame. I didn't notice that until I developed the film. *Portland, Oregon*

PATRICIA HURLEY

The image reproduced here is from a series made during my second pregnancy. My original intention was to record my body's visible physical changes, but as time passed I became more interested in exploring the changes that were occurring in my thoughts about women as childbearers.

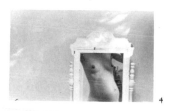

Patricia Hurley graduated from the College of St. Elizabeth in 1963. Since then she has earned her living by writing and taking photographs. From 1966 to 1973 she worked in Europe and has since been in Washington, D.C. *Reston, Virginia*

DE ANN JENNINGS

These images are from the *Fears and Phobias* series. Although they are personal, I feel most people can identify with them.

The chain and white glasses image is the first photograph of the series. It deals with my fear of the possibility of being confined in a traditional woman's role and not being able to see (realize) my capabilities. At that time I was questioning my role as a woman and as a person. I believe I have now crossed that hurdle.

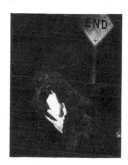

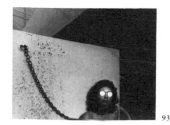

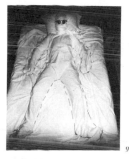

The other images are less symbolic, although *The End* represents my fear of death and the unknown.

Most deal with fears typical to many people although probably more so to women: rape, ritualistic murder, bondage, and electrocution (more of a personal phobia related to a childhood experience). The electrocution photo is also a takeoff on the famous photograph of the last electrocution (execution) of a woman.

I was born and raised in the small Mormon community, Manti, Utah. I was always somewhat rebellious, especially toward traditional rules and regulations I thought were unnecessary or wrong. (This may carry over somewhat to my rebellion against traditional photographic rules—especially that photography should be a document of reality.)

I went to the University of Utah, where I received a degree in biology. After graduating I moved to California and taught biology and ecology on the high school level. This fascination and fear of scientific technology shows itself in the work.

About seven years ago I took an old Argus to Hawaii and discovered I might have some creative talent in photography. I pretty much learned the technical aspects on my own, but went to California State University, Fullerton, to learn more about the aesthetics. I received my M.A. about two years ago.

Since that time I have continued to do my own work, free-lance, and teach at several colleges. *Los Angeles, California*

JOYCE JOHNSTON

Joyce Johnston graduated from Boston University in 1973 and in 1976–77 she attended the Visual Studies Workshop in Rochester, New York. *Waimanalo, Hawaii*

49

16

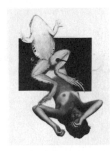

17

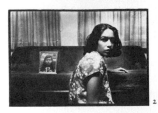

2

14

EVE KESSLER

Untitled (2)

My dad has always been big on snapshots. Throughout my childhood he would place me somewhere and have me wait for long periods of time while he focused, composed, and readjusted. When I look at those old photos I remember my discomfort, waiting, squinting until the click. This one, taken when I was seven years old, has always been a family favorite. I am interested in the continuity of past and present appearance, expression, and emotion as seen through photographs of one's life.

I always wanted to look like my father. (14)

Eve Kessler received her B.A. from Franklin and Marshall College, where she was a member of the Phi Beta Kappa Society. She received her M.F.A. from California Institute of the Arts in 1976. Her shows have included Sequential '77 at the Harkness House and Self-Portraits at the Mid Town Y Gallery in New York City, and she has been a staff photographer for *Synapse: The Jewish Women's Quarterly* in New York City. *New York, New York*

JOANNE LEONARD

Variations on a Sleeping Theme

I had a small Polaroid print of myself sleeping which I once made by remote control. It seemed unimportant. My sleeping dog photograph, on the other hand, haunted me with its vulnerability. Later, I reproduced the dog picture in a size as small as the Polaroid print, and suddenly the two images seemed to take on a new presence as each one played off the other.

Journal Entry (Woman and Frog)

This is a page taken from a collage-journal begun when I was pregnant, and continued through a miscarriage and a subsequent period of longing. The frog, in her supine posture, seemed brazenly receptive. This picture of me mirrored that posture. This self-portrait reflects this time of desire for insemination and maternity.

Joanne Leonard has taught at Mills College, Cornell University, and San Francisco Art Institute and has been published in *Life Library of Photography* and *From the Center*, by Lucy Lippard. In 1978 she received a NEA Photo Survey grant. Her photographs have been shown across the country, including exhibitions at M.I.T., Seattle Art Museum, San Francisco Museum of Modern Art, Cornell University, Museum of Contemporary Crafts and the Light Gallery in New York City, Pasadena Art Museum, Focus Gallery and M. H. De Young Museum in San Francisco. She is currently Assistant Professor of Art at The School of Art, University of Michigan. *Ann Arbor, Michigan*

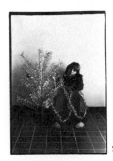

KATRINA LASKO

Joy

'It's awfully considerate of you to be thinking of me here and I'm most obliged to you for making it clear that I'm not here . . .'
—Kent Smith, 1978

Katrina Lasko is a photographer and graphic artist for the Desert Research Institute in Reno, Nevada. She has also edited *Brushfire*, an art and literary publication. Her artwork has been shown in numerous exhibitions throughout Nevada. *Reno, Nevada*

55

LINDA LINDROTH
Nude Descending a Staircase

As I am a firm believer in the anecdote as history I give you the following.

In 1971 I left my job with a publishing company to do freelance photography and picture research. I received a call from a college friend who was researching illustrations for a college text on writing which was going to be published by a major New York City publisher. She needed a photograph to go with Duchamp's 'Nude Descending a Staircase.' 'Muybridge,' I reminded her. 'Yes, but you see there's pubic hair visible and we can't use it!' Could I take a photograph that had no pubic hair? Well, I did and this is it.

Incidentally, this is my first self-portrait and the first time my nude body appeared in print. I was a bit nervous about this, not so much because of the nudity per se, but because I did not feel that my body would stack up against the great nudes of history. So I told everybody, including my friend who used the picture, that it was a photograph of my cousin!

Generally, I suspect that I photograph myself to see someone who looks like me. I do not have any brothers, sisters, or children—I always wanted a sister. Sometimes I do multiple exposures or, with the Polaroid SX-70, extremely low exposures where I move around from spot to spot. The photos that result from this movement give the illusion that I have a twin or that I am one of triplets. I very much enjoy looking at these 'family snapshots.'

Linda Lindroth received her B.A. in studio art from Douglass College in 1968. She received a fellowship in photography from the New Jersey State Council on the Arts in 1974, and in 1975 published *Book*, a limited edition, mixed-media book/object. In 1976 she studied with Garry Winogran. Her photographs have been exhibited in Eight American Women Photographers (a USIA traveling show throughout Germany and Italy, 1975–76); Photo/Synthesis, Cornell University; and Photographic Process as Medium, Rutgers University. Her work is included in collections in the Museum of Modern Art, Metropolitan Museum of Art, Bibliothèque Nationale, New Jersey State Museum, and Musée d'art et d'histoire in Fribourg, Switzerland. She currently teaches photography at Douglass College. *Florham Park, New Jersey*

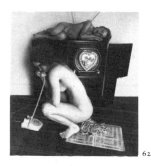

JACQUELINE LIVINGSTON
Better Phone Home—Gut Shit

This photo was made as a response to a telephone company advertisement which used the slogan: 'Better Phone Home.' The ad pictured a wife and children waiting anxiously, looking pathetic and upset because 'he' had not telephoned. My photograph casts me as the 'wife' answering this all-important caller.

Jacqueline Livingston was born in 1943, received her M.A. from Arizona State University, and since 1975 has been an assistant professor at Cornell University. She has had one-women shows at Ohio State University, Diablo Valley College, Contemporary Arts Center of Cincinnati, and Oberlin College, and has been included in group shows across the country. Her photographs have been published extensively and appear in *Artweek*, *Ms.*, and *Vision and Expression*, Horizon Press. Her photographs are included in collections at the Museum of Modern Art in New York, the George Eastman House in Rochester, the Contemporary Arts Center of Cincinnati, the Kalamazoo Institute of Arts in Michigan, and the Oakland Museum in California. *Ithaca, New York*

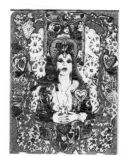

JILL LYNNE
The Queen of Hearts #III

This is a self-portrait presented as Xeroxgraphy on acetate with mylar, and the third piece in the *Queen of Hearts Triptych*. The 'negative' for *The Queen of Hearts* is composed of my primary photographic image, the self-portrait, collaged with 'recycled material,' images obtained from other sources—drawings and hand-coloring.

The image continues my work of six years in self-portraiture. For the past five years I have been creating a 'Valentine's Day Self-Portrait Piece'; this is a time to regularly 'take stock' of my emotional life.

Jill Lynne is a photographer, an arts administrator, and a photography teacher whose work has been extensively published and exhibited. She is currently the director of the PHOTO-FLOW Foundation for Photography and Art and is working on a monograph which is to be published by Morgan & Morgan in the winter of 1978. Her one-woman exhibits include the Neikrug Gallery, the Steiglitz Gallery, and the International Center of Photography. She has published in *Popular Photography*, *Viva*, and *Ms.* Her work can be viewed at the Witkin Gallery in New York City. *New York, New York*

 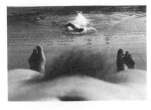

ANN MANDELBAUM

Untitled (6)

This image is representative of the general duality which infiltrates my work. It emanates from a philosophy that views life as an enormous contradiction, flowing back and forth between the solid and the sensual— and the illusive.

Untitled (38)

This image, shot on the hills surrounding Edinburgh, Scotland, crystallizes the confrontation of such duality.

Ann Mandelbaum received her M.A. in Media Studies from Antioch College in 1976. She presently teaches photography at the New School for Social Research and Pratt Institute, New York, and is also artist in residence in film and photography in the N.Y.C. public school system. Her work has appeared in numerous group and one-woman shows and has been published in *Ms., Women See Men,* and *Women Photograph Men. Brooklyn, New York*

ROSALIND KIMBALL MOULTON

I was studying myself in relation to sexuality and sensuality.

Rosalind Moulton was born in Buffalo, New York, in 1941. In the mid-1960s she was a Peace Corps volunteer in India. When she returned to America she spent three years as a partner in Kimball-Rankin Architectural Photography, a two-woman business in Cambridge, Massachusetts. She received her B.F.A. in photography from School of the Art Institute of Chicago in June, 1971, and received the Anna Louise Raymond Traveling Fellowship which she used to support eighteen months spent in India studying a Sufi community. She has taught photography at Purdue University and S.U.N.Y. at Buffalo, and since 1976 has been the sole instructor in photography at Stephens College. Her prints have been published in *Light* and *Octave of Prayer,* Minor White, editor; and *Vision and Expression,* Nathan Lyons, editor. *Columbia, Missouri*

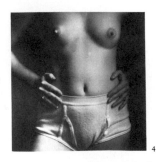

KATHY MORRIS

Fruit of the Loom

It's fun to jolt people with the fact that I wear 'men's' underwear. (I tell them: it fits better, it's cheaper and more durable than the crap that's sold to women, so why shouldn't I wear it?) It's a *spoof* on feminism and androgyny, as well as *being* feminist and androgynist. A mustache on the Mona Lisa, art history in jockey shorts. Women's bodies are often compared to fruit—here's my *Fruit of the Loom,* frontal version.

Kathy Morris was born in New York City in 1949. She received her M.F.A. in painting and photography from Cornell University in 1976. Grants which she has been awarded include the Cornell Graduate Research Fellowship and the America the Beautiful Fund. She is currently working at CETA jobs involving community arts and public relations, exhibits and publishes in the Ithaca area, and is designing a course on 'The Woman Photographer, Past and Present.' *Ithaca, New York*

CAROL MURRAY

Carol Murray was born in 1951 in Massachusetts. She received her B.A. from Barnard College and is currently living in New York City. *New York, New York*

JUDY NATAL

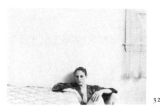

You have to make up your mind to be alone in many ways. It is easier to be in company than going it alone. But alone, one gets acquainted with oneself, grows up and on, and if you succeed you may pay for it as well as enjoy it all your life.

I currently reside in Rochester, New York, where I am completing my M.F.A. thesis in photogravure and photo etching at the Rochester Institute of Technology. I received my B.F.A. in design at the University of Kansas, where I initially began my investigation in the noor silver processes. I have exhibited throughout the United States and maintained residency in Chicago, where I was born and raised. *Rochester, New York*

BEA NETTLES

98 *Christmas Doll* from *Ghosts and Stitched Shadows*
99 *Christmas Gun* from *Ghosts and Stitched Shadows*
100 *Swan(song) dream* from *Bea and the Birds*
101 *Lake Lady as a Young Girl* from *Ghosts and Stitched Shadows*

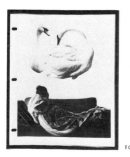

102 *Summer of '70*
103 *Lake Lady Legs* from the *Neptune Series*

These are a selection of autobiographical notebook pages from unique books made in 1970–1971 during my first year of college teaching.

The *Neptune Series* parallels a short-lived relationship I experienced during that time. *Ghosts and Stitched Shadows* were the first images I ever made from family snapshots in an attempt to recall a more secure and happier time.

Bea Nettles currently teaches at Rochester Institute of Technology. She has shown her photographs internationally at major exhibitions and is represented by Witkin Gallery in New York City. The most recent of her eleven self-published books is *Breaking the Rules: a Photo Media Cookbook*, a textbook on alternative processes. Her work is also included in *The Woman's Eye, A Chronology of Photography*, and numerous magazine articles. *Rochester, New York*

BARBARA NORFLEET

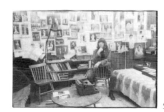

About seven years ago I borrowed a camera and took some pictures. The result was a move away from a seventeen-year career in sociology toward photography. I now take pictures, I curate shows, and I collected for, organized, and now direct the Photography Archive at Harvard University.

This picture was taken in 1976. I had been alone all day working on the final selections for a photographic show on getting married in America. I suddenly realized that although I had been on the Harvard faculty for most of my adult life, this was the first time that I was taking myself and my work seriously. I had a camera and I took the picture. It was just right.

Barbara Norfleet received her B.A. from Swarthmore College in 1947 and her Ph.D. from Harvard University in 1950. She has been a member of the Harvard

faculty since 1960 and has received grants from the Massachusetts Council of the Arts, the National Endowment for the Humanities, and the National Endowment for the Arts. Her work is now part of the collection at the Museum of Modern Art, New York. *Cambridge, Massachusetts*

C.K. OPPENHEIMER

Inheritance

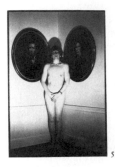

Inheritance is one of a series of self-portraits prompted by Eileen Berger's photography course at Moore College of Art. I value the photograph for its immediate and humorous impact; a spur-of-the-moment inspiration, it resolved my childhood fascination with the paintings of my great-great-great-grandparents and revealed the essence of my emotional inheritance.

59 C.K. Oppenheimer received her B.S. from the University of Wisconsin, Madison, and then studied at the Tyler School of Art and the Pennsylvania Academy of Fine Arts. She has been an elementary and secondary school art teacher. Since 1975 she has been in the Continuing Education program at Moore College of Art in Philadelphia. She is married and has two children. *Jenkintown, Pennsylvania*

CHRISTINE OSINSKI

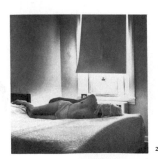

This photograph is taken from a group of photographs called *The Bedroom Suite*. These self-portraits are concerned with sexual identity and notions of beauty and nonbeauty and bodily relief. I did this work with anger, affection, and humor.

26 Christine Osinski was born in Chicago. She received a B.F.A. from the Art Institute of Chicago and an M.F.A. from Yale University. She presently teaches photography at C.W. Post College and also at the Bedford Correctional Facility for Women in New York. She has exhibited nationally and internationally in numerous one-woman and group shows. *New York, New York*

CHRISTINE PAGE

The way I saw myself before becoming a photographer

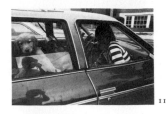

When I was in college, my friends in the art department and I would often discuss the likelihood of who among us would end up with 11 the typical suburban trappings: a panel station wagon, babies and dogs. It was not so much a matter of who was most likely to succeed, but who was most likely to succumb. It had overtones of giving up your art and your personal work/growth for more traditional and acceptable roles.

In my self-portrait, my doing what I love (photographing) is reflected off the shiny surface of what I'd thought I'd end up doing; I'm looking at the person I'd thought I'd be.

Christine Page received her B.F.A. from University of North Carolina, Greensboro in 1970, taught photo and graphic arts in Alaska from 1971 to 1976, and is presently an art education graduate student at Arizona State University, concentrating on photography and photo history. She has published an article in *Northlight* magazine and has exhibited at the 4 Corners Juried Exhibition, Arizona State University Art Department Gallery, and the International Center of Photography, New York City. *Scottsdale, Arizona*

CYNTHIA PARARO

TNIOPRETNUOCCOUNTERPOINT
associate relate
animal vegetable mineral
knowledge knowledge know
(builds bridges) edges no

I, Cynthia Lee Pararo, Tallahassee Memorial Hospital, 1953; loved and learned in Tallahassee for twenty-four years, then journeyed further Florida (Tampa) to form my M.F.A.

In 1977, my photographs won purchase and merit awards in exhibitions in Florida, New York, 68 Virginia, and California. *Tallahassee, Florida*

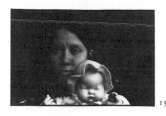

KAREN A. PEUGH

Me and Baby Dear

Dolls played a wonderful part in my early life. I received this doll for Christmas when I was nine. For a month before this particular Christmas I imagined her in my bed, lying on a feather pillow next to me. My mother let me play with her once before Christmas. I knew I was growing up, that getting dolls at Christmas would not go on much longer. When I had a show of my self-portraits in 1973, I took some of my dolls, including 'Baby Dear,' to the gallery. This picture was taken at that moment.

Karen Peugh received her B.A. from Antioch College and her M.F.A. from the School of the Art Institute of Chicago. She is a video and photography teacher in Chicago area schools and is also an independent video and film maker. *Chicago, Illinois*

HILDY PINCUS

Self-Portrait, 1975

An empty couch, the late afternoon light, a portrait of two people holding hands, now dead, a sad memory of something I thought was there, but now an emptiness, a loss I can't explain. (This is what I saw, and felt, and photographed.)

Hildy Pincus received a B.A. in liberal arts from Pennsylvania State University and an M.A. in anthropology from C.U.N.Y. in 1974. She has studied photography with Cora Kennedy, George Tice, Sean Kernan, George Alpert, and Charles Gatewood. Her work was exhibited in a one-person show at Soho Photo, New York City, in 1977. *Brooklyn, New York*

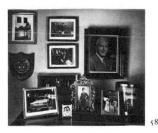

MARY PITTS

There are many conflicting facets of my life which are forced to compete and coexist. I often feel strange and uneasy in what I believe is expected of me in my various roles as wife, mother, photographer. For this photograph I changed a display of family photos and objects in my bedroom to make visible the uneasy alliances within me.

Mary Pitts received her B.A. in French from New York University in 1962, her *certificat* from Université de Paris in 1963, and her M.A. in French from Columbia University in 1966. Before moving to California, she taught French language and literature in Cleveland, Ohio. She began studying photography in 1972. Her work has been exhibited at the Centre Culturel Americain in Paris, the California Expo, 1977, in Sacramento, and the N.O.W. Showing of California Women Artists in 1977. She is presently working and living in San Francisco with her husband and two children. *San Francisco, California*

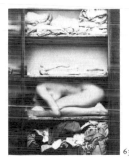

KAREN PLESUR

On one level this image conveys my search for identity as a woman in today's society, which I was then exploring. Self-portraiture allowed me to become more aware of my individuality. This picture conveys my view of the prior emphasis on keeping women in the closet, hiding their true feelings and self-esteem.

On another level this image humorously reminds us how society still associates the female with the linen closet and its contents.

Karen Plesur received her B.A. in photography from San Francisco State, and her M.F.A. from Lone Mountain College. She has worked as a teacher, a commercial photographer, and an art director. Her work has been exhibited in numerous solo and group shows in the California Bay Area. *San Francisco, California*

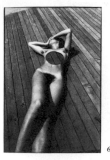

DINAH BERLAND PORTNER
The Shell (1976)

On September 4, 1976, I made the following entry in my journal: 'I am hurting . . . I feel weak and dead and empty . . . there is a big round hole that has been cut out of the center of me—just an empty space that the cold wind can blow through. And still I walk around as though I am alive. But I am not.' This photograph was an attempt to make that emotional state visible.

Dinah Berland Portner attended the University of Michigan, received her B.F.A. in painting from Wayne State University in Detroit, and is a graduate student in art/photography at California State University at Northridge. She has taught art and writing for the gifted in the Los Angeles school system and does public relations work for the Los Angeles Center for Photographic Studies. Her photographs have been included in group exhibitions at Soho/Cameraworks Gallery, Los Angeles. *The Shell (1976)* was first published in *Combinations, A Journal of Photography. Los Angeles, California*

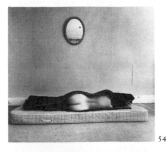

SKYLER RUBIN POSNER
Self-Portrait According to Gertrude Stein ('That's the Answer')

People tend to take themselves very seriously and artists are the worst offenders. Our suffering, we say, makes us profound. And the despair we take care to depict in our art insists on respect. Hell, I've just learned to blow bubbles and I want to tell you that life's not all gray and grim and that being forty, or being a woman, or being an artist, or a member of the human race isn't all that terrible. In fact it's just about what you make it and that's what this series of self-pictures is about. I've had my share of sorrow and soul-searching for the why's and wherefore's of existence, but I tend to agree with Gertrude Stein that the only answer is that there is no answer. So let's keep it light where we can and just get on with life.

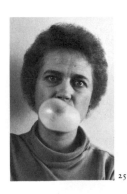

Skyler Rubin Posner received her B.A. in music from Mills College in 1961. She became interested in photography in 1976, and since then has exhibited in the Aperture West Coast Regional Conference, Artists in Response, and the Focus Juried Photographic Salon. She has also been the subject of feature articles in *California Today* and *California Living. San Francisco, California*

VICKI LEE RAGAN
New Shoes (50)

My work is very personal. It's like a visual diary. I try not to make self-portraits, but just to let them happen.

Vicki Ragan is a graduate of Colorado Mountain College (A.S. in commercial photography) and the Chicago Art Institute (B.F.A.). She has worked as a commercial photographer since 1973 and has shown her own work in Denver, Santa Fe, Iowa City, and Chicago. In the fall of 1978 she will be working on her M.F.A. at the University of Arizona, Tucson. *Greenley, Colorado*

SHAWNA REILLEY

I made this photograph during the time period when I was feeling good about myself sexually, and wanted a photograph of my body shining. I noticed a sliding board reflecting light, decided it would complement shining skin, and made this photograph while sliding.

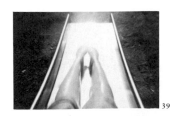

Shawna Reilley received her B.A. from the University of Delaware in 1974 and her M.F.A. from Ohio University in 1977. She is currently working as a video production assistant for Community Media Workshop in Wilmington, Delaware. Her photographs have been exhibited at Fifth Street Gallery and Delaware Art Museum in Wilmington, Delaware; Artifacts Gallery and Seigfred Gallery in Athens, Ohio; and the Dayton Art Institute in Dayton, Ohio. *Newark, Delaware*

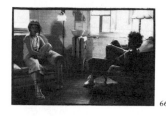
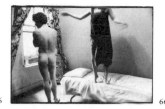

66 66

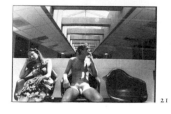

21

JANE SCHREIBMAN

The Ladies

This is a photograph of my friend Jessica Weiss and myself, taken in the living room of her loft. It was originally planned as a fashion photograph but as I thought about it I realized that what I actually had in mind was a self-portrait. We got fancied up and did our own interpretation of a fashion photograph.

Inside the Irving

This is a photograph of Peter Hutton and myself taken inside the Irving Hotel, a transient hotel in Manhattan. The room itself was like an empty set so I filled it with some action and made the photo. The action I chose was a dramatization or exaggeration of my own feelings about the situation at the time.

I studied photography at the San Francisco Art Institute, then came to New York and have been here for the past five years. I have worked for *New York Magazine* and am involved in various aspects of film-making. I have also produced and co-edited a video tape on battered women. *New York, New York*

SOLEDAD CARRILLO SHOATS

Le Camisole 20

The image *Le Camisole* deals with an aggressive 'if you can' sexual come-on, with the idea of the 'femme fatale.'

Untitled

This is the initial photograph from a handmade book titled *Le vrai Nouveau Roman, photographique autobiographique et Féminin.* The narrative under the photograph reads: 'It was already wrong when I came home. I'd forgotten the keys and had to ring the bell. Sam had to get out of bed to answer the door and he wasn't too happy.'

This photograph, with its three-dimensional background in space, is an attempt to explore the distance and alienation, the façades and the waiting that often occur in personal relationships.

Soledad Carrillo Shoats received her B.A. in 1976 from the University of New Mexico, majoring in Spanish, and in 1975 studied at the University for Foreigners in Perugia, Italy. She presently teaches Italian in the Albuquerque public school system and is a graduate student in photography at the University of New Mexico. *Albuquerque, New Mexico*

37

LINDA J. SCHWARTZ

Photography is a very personal thing for me. When I set out to photograph, I am drawn to isolated places where I am totally alone. In such spaces I feel at peace with myself, in harmony with nature. This photograph is a visual statement about my relationship with nature, about the underlying unity of organic and inorganic forms.

In the middle of a liberal arts education at Boston University, I decided to return home to Chicago and learn something concrete. I attended Columbia College, where I studied radio broadcasting and creative writing, but it was photography that held my intense interest from the beginning. I am currently working on my master's degree at the Institute of Design and am employed by the Chicago Council on Fine Arts as an Artist-in-Residence. *Chicago, Illinois*

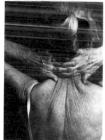

71

NINA HOWELL STARR

Considering Myself

One of numerous attempts to represent my knobby arthritic hands in portfolio (*A Room of My Own*). Its components: those lines shooting down my back, the curl of my ponytail, the twist in the shoulder strap, and the force of my thumbs and thrust of my arms, all communicate something of what I like to consider myself.

Photography is Nina Howell Starr's third life, established with her M.F.A. in 1963 from the University of Florida. Her work has most recently been included in Self Portraits, the Mid Town Y, New York; Women's Art Symposium, Indiana State University; and Images of Women, Portland Museum of Art, Maine. Her photographs have been published in the Portland Museum catalogue, *Women Photograph Men*, *Women See Men*, and *Women See Women*. *New York, New York*

MARILYN SZABO

Portrait photography interested me, but it had been mostly a failure. The only successful portraits had been self-portraits. While studying other photographers' works I became interested in the photograph *Portrait in Window-* 61 *light* by Evelyn Hofer. Ironically, a friend had painted this photograph; it hung in my apartment. Frequent experiments (various lighting situations with people) hadn't worked. This image was an impromptu one. My camera was loaded, the afternoon sunlight approached, I saw the image and shot.

Marilyn Szabo received her B.A. from Virginia Commonwealth University. She is presently employed with the National Park Service at Carlsbad, New Mexico. She has exhibited at Huntington Galleries, Huntington, West Virginia, and the Virginia Museum, Richmond, Virginia. *Carlsbad, New Mexico*

JANE TUCKER

Nudes in the Attic

I call these images *Nudes in the Attic*. At the time they were made, I was renting a room in the home of a family with daughters. Their attic was filled with ski boots, Buddha statues, silver prom shoes, doll houses, and almost everything that stood for my past (in my family there are four girls). Instantly, I began photo-graphing myself in a large mirror. These 35 photographs gave me the freedom to act out my different selves.

Jane Tucker graduated from the University of Denver with a B.A. in psychology and education. She was employed at Brush Ranch School as a live-in counselor to children with learning disabilities. There, she took up photography, teaching herself and her students. Her photographic education began at the Banff School of Fine Arts in Alberta, Canada. She has taught community photo classes in Alabama and is presently working on her M.F.A. in photography at Ohio University. *Athens, Ohio*

PAMELA VALOIS

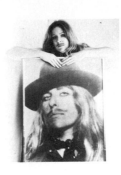

The poster in this photograph was made in early 1970 from a 25¢ snapshot-booth photo taken on the Santa Monica pier. I was living alone and liked to walk at night; the only way to do it without attracting attention was to 'become a man.'

The initial response from male friends was mild until the identity was dis-closed; the resulting response has 27 been uniformly negative and anxiety-producing.

Two years ago I photographed myself with 'myself.' Need I say there are many times when I still feel the need to *appear* to be a man?

Pamela Valois studied with Ruth Bernhard in San Francisco. Her photos have been published in *Not Man Apart, New West, Moment, Book Digest,* and *Popular Photo.* Her main project to date has been to self-publish a 1978 calendar, *Don't Call Me Sweetheart. Berkeley, California*

BERNIS VON ZUR MUEHLEN

This photograph is about death and mem-ory. It contains a photo of my mother and me when I was a child. She's dead now and my memory does not include the young woman in the photo. The final image is at once nostalgic and painful for me. It's about what is real and what isn't. I have difficulty remembering my childhood.

Bernis von zur Muehlen was born in 1942 in Phila-3 delphia. She received her B.A. degree in literature from the University of Pennsylvania, graduating with honors and membership in the Phi Beta Kappa Society. Her photographs appear in *Light-work, Women See Men,* and *Women Photograph Men. Reston, Virginia*

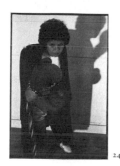

NAOMI WEISSMAN
The Photographer as Muhammad Ali
(in collaboration with Sally Weare and
Debra Heimerdinger)

I was invited to a costume party and told to
come as my favorite character. That week I
had a dream that I went to the party with
Cassius Clay. I thought the dream was apt
and funny and decided to act out my wish
for power by actually going to the party as
Muhammad Ali. By chance, a friend of a
friend had an entire Muhammad Ali outfit—
boxing gloves, white satin trunks, a 'float like a butterfly' T-shirt—
which he loaned me. Before the party two friends and I decided to
photograph me as Muhammad Ali.

The experience was catalytic. It became apparent that by physically
altering my persona, I could alter my perceptions about myself. As a
result of the experience, I have written a workbook of photographic
self-portraiture with a friend, Debra Heimerdinger. It will be entitled
Self-Exposures, and will be published by Harper and Row in the spring
of 1979.

I was born in New York City in 1940 and moved to Berkeley, California, in
1972. I enjoy taking photographs of people, including myself occasionally. I have
recently created a hand-printed book of photographs entitled *Native Dancers*
and had solo exhibits in San Francisco and London. I am currently at work on a
sequel to *Native Dancers* entitled *Perfect Strangers. Berkeley, California*

ANN F. WENZEL
Self-Portrait with Bruce

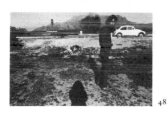

Bruce was my photo instructor
at Arizona State University.
He helped me develop a part of
my personality that I had tried
to keep hidden. The shadow is a
self-portrait of my secret self.
The desert is also an important
element in this photo, as it symbolizes my change to a new environment,
which was an important step in my personal growth.

Ann Wenzel was born in Marshfield, Wisconsin, and raised in a family of six
children. She began photographing at the age of eleven. In 1976 she graduated
from Arizona State University in Tempe with a B.A. in Art and will attend law
school in the fall of 1978. She has exhibited in shows throughout the West and in
New York. *Marshfield, Wisconsin*

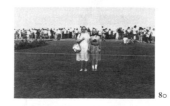

80

81

82

83

84

85

SUZANNE WINTERBERGER
80–84 *Untitled*
85 *Imitating Saguaro Cacti*

My photographs are made to check and document my relationship to
the world as I move through it. In a sense, I am both tourist and tourist
trap. Self-portraits become a fantasy outlet, a form of daydream which
can be quickly acted upon and smiled about afterwards. I see myself as
a character poking around the edges of the 'all-American fantasy'—at
times I am at once participator, director, and recorder of this ritualistic
behavior.

Suzanne Winterberger received her B.F.A. from Rochester Institute of Technology
and her M.F.A. from Cranbrook Academy of Art, Bloomfield Hills, Michigan.
She has been a photographer for the Rochester Bicentennial Commission, the
Delaware and Hudson Canal Restoration, and the Cranbrook Academy of Art
Museum. Her work has been exhibited at Buffalo State College, Rochester Insti-
tute of Technology, Cranbrook Academy of Art Museum, and Camerawork Ltd.,
San Francisco. *Vestal, New York*

133

CHERYL YOUNGER

This image comes from a series taken during the pregnancy and birth of my daughter. I instinctively knew this was an important time and yet felt nothing. Great warmth, laughter and pleasure welled up in me as I drove into the Coral Fruit Market that day. Here was something I could relate to after months of feeling awkward and pubescent.

Cheryl Younger is thirty-one and lives in Iowa City with her daughter Mercedes and her husband Dan. She has a B.S. in business and an M.A. in photography. She completed her M.F.A. in photography one day before her daughter's birth. She has taught, exhibited regionally and nationally, and most recently had a portfolio of prints published in *Popular Photography Annual 78*.
Iowa City, Iowa